LIGHT AND LIFE IN THE MIDDLE HILLS

LIGHT AND LIFE IN THE MIDDLE HILLS

A photographer's perspective of life in Nepal

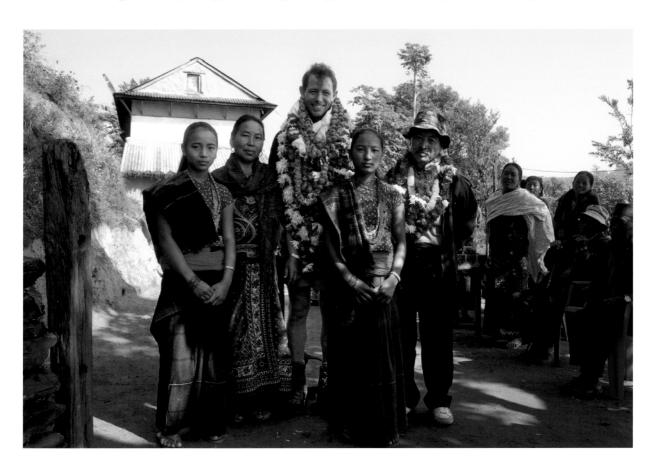

JOHNNY FENN

This edition first published by
Uniform
an imprint of Unicorn Publishing Group

Unicorn Publishing Group
101 Wardour Street
London W1F 0UG

© Unicorn Publishing Group, 2016
www.unicornpublishing.org

A catalogue record for this book is available from
the British Library

ISBN 978-1-910500-42-2

Printed and bound in Spain

ACKNOWLEDGEMENTS

My heartfelt thanks for their support to "Light & Life" and the book launches on 25th April and 12th May 2016 go to:

Lord and Lady Weymouth and the staff at Longleat House

Air Commodore Nigel Beet and the staff at the Victory Services Club

Colonel William Shuttlewood and the staff of the Gurkha Welfare Trust

Lieutenant Colonel "Patch" Reehal and the Officers and soldiers of the Queen's Own Gurkha Logistic Regiment

Prashant Kunwar, Khukuri Beer

Julian White, Gurkha 200 Champagne

Dennis and Pat Fenn

FOREWORD

Johnny has always seemed very at home in Nepal; it was there, while he was a Lieutenant Colonel working as the Field Director for the Gurkha Welfare Trust, that our paths first crossed in 2011.

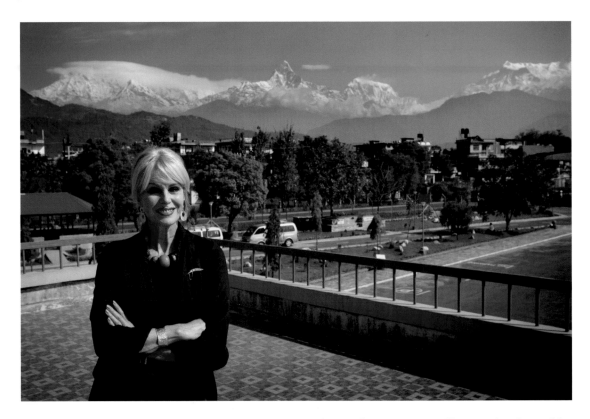

Gurkhas have always played a significant part in my life. My father was an officer with 6th Gurkha Rifles, and as child I travelled with the regiment across the world, from India to Hong Kong to Malaysia. I came out to Nepal following the death of Lieutenant Tulbahadur Pun who had won the Victoria Cross in Burma whilst serving with my father. In the remote hillside village in which he had lived we had built a new school in remembrance, and I was there for the dedication: and Johnny had put in place all the arrangements for me.

Since then I have followed his progress from smart army officer to brilliant, bearded, bohemian photographer. He has developed a growing business, whilst discovering that becoming your own boss doesn't necessarily make one's life easier.

In contrast to his military life based in barracks around the world, Johnny is now commander over an entirely new block: his studio, based in Mere, a village straddling Wiltshire, Somerset and Dorset. And yet he has not shackled himself there. Like me, he has a unquenchable love for travel. Since leaving the Army he has photographed in Afghanistan, Switzerland, Iraq, Libya, the Arctic, Poland, Norway … and of course Nepal.

Despite this glamorous-sounding lifestyle, there is a very serious side to what he does. This book lends a voice to those who have not had easy lives. Many of the faces you will see mask the depravations of living in the Middle Hills of Nepal. Life in this stunningly beautiful country has always been hard and, since the 2015 earthquake, especially hard. Johnny's images, many within this book, have highlighted the plight of those villagers and the campaigns to raise funds to help them.

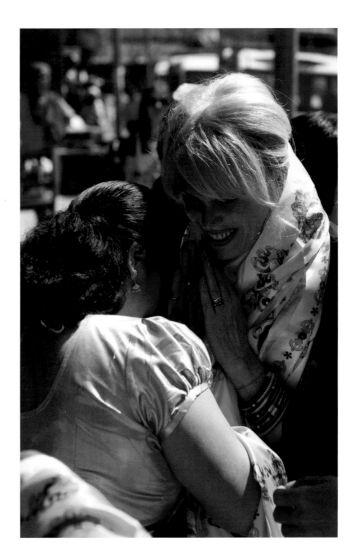

As you turn the pages of this remarkable book, I hope, like me, you will be transported to that stunning, flawed, valiant, romantic country that is Nepal. Here we come face to face with a people from a faraway land whose lives are incredibly tough, but whose spirit and bravery shine out from the photographs: a real testament to Johnny's love of Nepal and its people, a love that makes this collection of images such a treasure.

Joanna Lumley

INTRODUCTION

When you think of Nepal, it is impossible not to be drawn on the majesty and sheer awesome presence of the high Himalayas that run right across the northern border that separates Nepal from China. That range and those peaks, eight of which are among the ten highest in the world, play an obvious and fundamental part in what makes Nepal so very special. However, the story I present through my photographs in this book comes from trying to get to know a little of what Nepal is really about away from the towns and bazaars; the tourists and the hotels. Because, beyond these things, Nepal is so very special – intense, compelling and dramatic. And now new chapters are written in its history through the politics and struggles that continue to add to the hardships of these people every day. From the time when Nepal consisted of many small feudal Kingdoms, to the unification of Nepal in the mid-1700s by the King of Gorkha – Prithvi Narayan Shah, to the more recent struggles with democracy, to the murder of the Royal family in 2001, to becoming a republic in 2008, to the earthquakes of 2015. Every country has its struggles, but Nepal seems to be overly affected, and that drama is never far from the surface. Relevant to many of the photographs here was just one of those chapters that shaped Nepal; the Anglo-Nepal war of 1814–1816. This war led ultimately to the formation of units of Nepalese soldiers; the iterations of which are the Brigade of Gurkhas, and they remain a significant part of the British Army today. That military history is long and distinguished, and widely written about, not least in the incredible books by many former Gurkhas, including of course Colonel John Cross OBE, and very recently Major General Craig Lawrence CBE's book – *The Gurkhas, 200 Years of Service to the Crown*.

This book will touch on parts of that history, pictorially; some of the old soldiers who continue to live in Nepal, many in very straightened circumstances. Having been lucky enough to spend some time in and amongst these old soldiers and their wives or their widows, has allowed me an intimate and unique window into their worlds. The chance to hear the stories from 90-year-olds about when they, for the very first time, found themselves heading out of Nepal, through India and into some of the most ferocious battles of the Second World War in the Middle East and the Far East, and parts of war-ravaged Europe. I was also based at the centre of effort for Gurkha recruiting; in Pokhara, where I was able to witness the utter jubilation or the total heartbreak of those young men attempting to join the British Army as part of the Brigade of Gurkhas.

But much more than that, this book contains images of a snap-shot of life in Nepal of ordinary people who still live out their lives in this austere and dramatic landscape that is at once beautiful and at once unfathomable. I have called the book *Light and Life in the Middle Hills*. When I first joined the Brigade of Gurkhas I remember attending a lecture by a senior Gurkha Officer welcoming us

to the Brigade. He made the point that we recruit our soldiers from the "Middle Hills" of Nepal; where life was tough, conditions rugged, and assistance remote. The sort of conditions that if you were to recruit soldiers into the British Army and put them into situations where similarly austere conditions were found, then they might excel as soldiers. He was right, of course.

This ability to cope. This attitude of acceptance, fortitude and courage. These characteristics combined with loyalty and good humour make for a terrific soldier. But it also shapes the nature of those going about their daily lives, struggling with the challenges of staying alive in remote and arduous countryside of the Middle Hills. They are in every respect shaped by the landscape that surrounds them.

After the 2015, April 25th, earthquake, I was asked to photograph the villages at the epicentre. Those characteristics of fortitude and acceptance are those that have allowed these hardy people to continue despite the devastation. When I was there I met a five strong Malaysian charity medical team who had flown in two days before I arrived into the area. They were mostly medical doctors, but they were accompanied by a psychologist who had also been involved with other earthquakes across the globe. She told me she was very struck by the difference in the fortitude of the Nepalese, and the difference between here and other earthquakes was the clear desire of the locals to make the best of the appalling situation they found themselves in, and as quickly as possible.

I explain more about the earthquake at page 106, including some of the photographs I took at that time.

A bit of an explanation about me. I have always been a photographer. When I left school, I had passed the army officers' entry so I knew I was going to the Royal Military Academy at Sandhurst. However, I had several months to wait, so I worked as an assistant to the chief photographer for my local newspaper. I had studied photography at school as part of an Art A Level, and was keen. I had a Praktica MTL3, a very clunky East German camera that I fell in love with, and I had my own dark-room at home – the seeds were well and truly planted, but then the army took over and became my life. I did continue to take photographs, but I missed the fun of developing, and it wasn't until I got my first digital camera that I knew I would be a photographer again.

I took my first photographs of Nepal in 1999. I had just been posted to Brunei (where a Gurkha Battalion is still stationed) and was allowed a duty trek. I had two weeks in West Nepal and, like many British Gurkha officers before me, fell in love with the country, the people and the "Middle Hills". Since then I have been back many times. My final role in the army was as the Field Director for the Gurkha Welfare Trust. A brilliant job that allowed me to cross on foot most of the East and much of West Nepal while providing help through grants, medical care and welfare pensions

Major Krishna Gurung in Sabet village, West Nepal, standing by the house he was born in

brilliantly administered by the ex-Gurkhas and civilian staff of the Gurkha Welfare Trust offices based in Pokhara. At this point it would be remiss of me not to mention my first Deputy Field Director, Major Krishna Gurung MBE MVO for showing me the ropes and helping me sustain the "direction" needed in such a role. He is one of those incredible senior Gurkhas (of which there are many) who joined as soldiers and worked their way up to become Gurkha Majors of their respective Regiments within the Brigade of Gurkhas. Krishna has been an incredible example throughout his service in uniform and subsequently through his work with the Gurkha Welfare Trust. He has recently been appointed as the Trust's first Nepalese trustee.

The two years I spent in Nepal were probably the happiest of my military career. Working with a brilliant and energetic team while helping remote people of Nepal was challenging, but intensely satisfying. As well as that ex-Gurkha support that we provided, we also built schools and water projects, and provided medical camps in the villages surrounding the Gurkha recruiting areas. In many respects it felt like a way of saying thank you to these villages that had provided these amazing soldiers.

It was one of the school projects in a very remote village called Tiplyang that I met the incredible, delightful and unstoppable Joanna Lumley. She stayed with us in Nepal for a few days and the effect that she has is simply magical. The villagers at Tiplyang, I would think, have not seen "Absolutely Fabulous" or the "New Avengers" or any of the numerous brilliant documentaries that Joanna has made, but the welcome they gave her was testament to her personality and irrepressible charm. Her ability to engage with the villagers and the pleasure her presence gave was just outstanding. Obviously her upbringing in the Gurkha fold is incredibly important to her, and that light shines from her when she is among Gurkhas and Nepalis.

For my part, it was a terrific place to open a school that is going to help so many children from Tiplyang and the surrounding villages. Because Lieutenant Tulbahadur Pun VC is also buried there, it is a village that I hope to continue visiting in the future.

This school opening and visiting many other projects meant I wasn't tied to my desk in Pokhara. I spent many weeks out in the hills visiting potential projects and checking progress on those projects in chain. Usually these treks were with only a couple of Nepalese porters who speak very little English. It's a very good way of making sure your Nepali language skills are maintained!

I was sad to leave this wonderful role, but I did in October 2012, and with it I hung up my military uniforms and left the army. Since then I have been lucky enough to set up a photographic business which means I still get to travel around the world. Within these travels I have managed to return to Nepal two or three times each year.

It is now possible to get to many places in Nepal by four-wheel drive vehicle, or at least get close to most places you are trying to reach. It does depend on the season – landslides and floods are still commonplace, and routes are often blocked or completely destroyed. I made it a rule that I should try to get to as many of the Gurkha locations as possible on foot, and that remains the best way in almost every respect to see Nepal. Other times required big distances to be covered a little more quickly, so if the weather was favourable, a Land Rover was the perfect thing. In November 2014, I was on a commercial shoot for one of the other big charity and development agencies; the Kadoorie Agricultural Aid Association, and was very lucky to have the use of helicopter for a couple of days. That is a terrific way to get high up in the Himalayas in short order and witness incredible views that would otherwise be closed to you (see the picture on page 31). I travelled with their in-country manager, Al Howard. At one point, Siddhartha, the pilot, took us to 6,000 metres (almost 700 metres higher than Everest Base Camp) to cross a ridge-line into Langtang. Less than six months later, the villages in the Langtang district were almost all completely destroyed by landslides following the earthquake. The largest landslide was estimated to be roughly three kilometres wide. Many lives were lost.

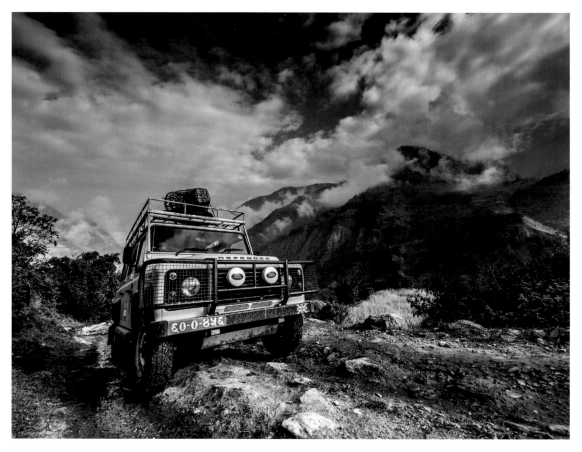

Nepal roads are challenging – even for Land Rovers

There are several things to bear in mind when travelling for prolonged periods in Nepal. Clearly you need to be prepared for all sorts of weather. It is invariably hot in the middle of the day, but temperatures can dip quite starkly at night especially if you have gained some altitude during the trek. If you trek after April and before September, then preparation for rain is a must. If you hit the monsoon properly, it can have a significant effect on your trekking routes and times. It also becomes dangerously slippery (although I have rarely seen the porters stumble). There are other things to consider, such as leeches if you are trekking through jungle, foliage or darker areas, and you are of course aware that landslides are a common factor during the monsoon, so routes are rechecked regularly.

The food on trek is another consideration. If the porters have their say, then *dal baht* would be served twice a day (most Nepalis eat only two meals a day – a late breakfast and an early supper). *Dal baht* is essentially steamed rice and a lentil soup, usually served with some cooked green

vegetable (known as *Tarkari*). If you are lucky, and the budget allows, you might get some chicken (which could be any part of the chicken other than the feathers…!) and perhaps some *roti*, a flat bread. After four or five hours of trekking; it is delicious. If you are feeling adventurous you might also try some of the local brews; perhaps *Thongba*, a millet-based alcohol with yeast and hot water, or a *Raksi* which is distilled from millet or rice.

The important thing I have learned while trekking is to make sure you have access to your cameras. If you are carrying too much gear and the camera is difficult to access (plus you are usually pretty tired) then the photograph goes begging. Much more important is to carry less, keep looking up, and have the camera at hand.

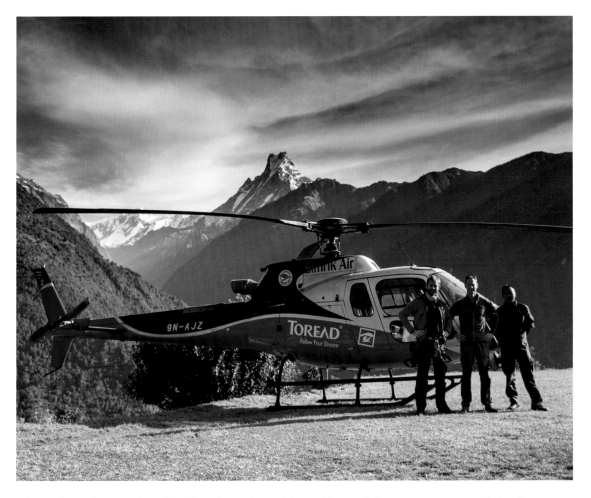

The Author, Al Howard, and Siddhartha with Machhapuchhre and the Annapurna range behind

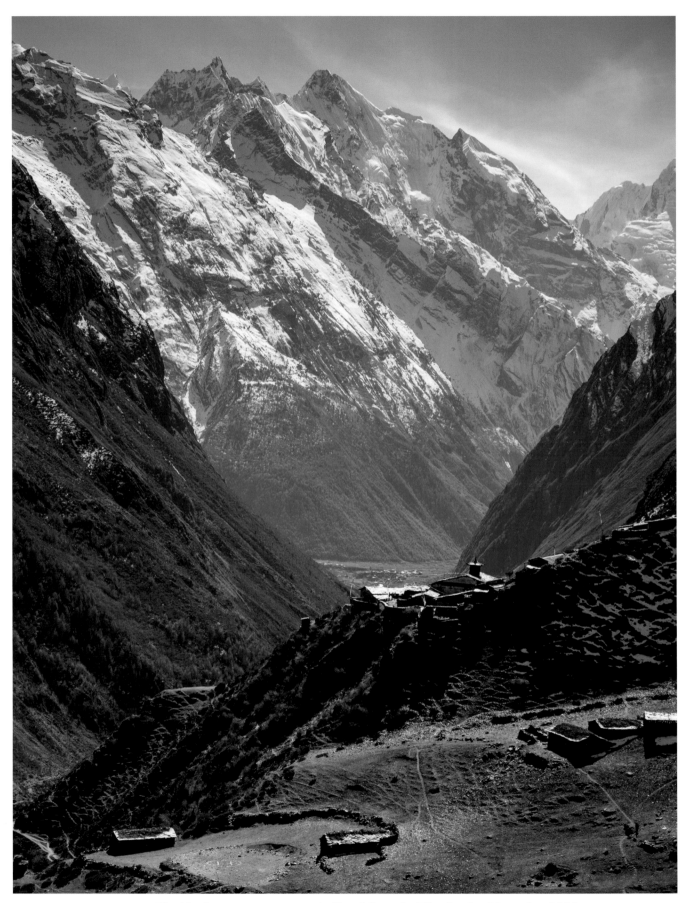

ABOVE: *The Northernmost monastery in Nepal from the Tibet border, November 2014*

THE PHOTOGRAPHS

(The technical bit!) Almost all photographs have been taken with a Nikon full-frame Digital SLR, a big, heavy (but importantly), robust camera. I travel with two camera bodies and four lenses almost always – the 14-24mm, the 24-70mm, and the 70-200mm are the zoom lenses, and then my favourite lens: the fixed 85mm f1.4. I take three flashes, or speedlights, with radio triggers, two lighting stands, two shoot-through umbrellas and a tripod. I prefer a heavy tripod as I know it will perform in all conditions. Carbon fibre tripods are great in terms of weight, but in my experience they can flex in rough weather. This all means I have to be prepared not only to carry it all (along with a laptop, various chargers, and my own clothes!) but also be disciplined when tired to get the right equipment out. When I headed up to Barpak just after the earthquake, the four hours of climb (main tracks had been destroyed) was tough with about 20 kg on my back. But it does pay dividends when you get to the location with the right equipment.

I do occasionally travel with two Fujifilm cameras (an X100 and and XT-1) These are much more portable, but still very capable with great sensors. A few of the photographs in the book are taken with these cameras, and they are ideal if I need to travel quickly or with less weight.

In the book I have not put the images in chronological order and I have tried not to group the photographs into too obvious a list. Instead I have used some broad categories that cover the overall subjects that I have photographed. I have also tried not to get into too much detail about an individual concern (other than the Gurkha Selection at page 101 and the earthquake that is found from page 106). I hope in this way, I have shown a little bit about what it is that I have found so special about Nepal, and I hope that in some way I have allowed you to feel that too.

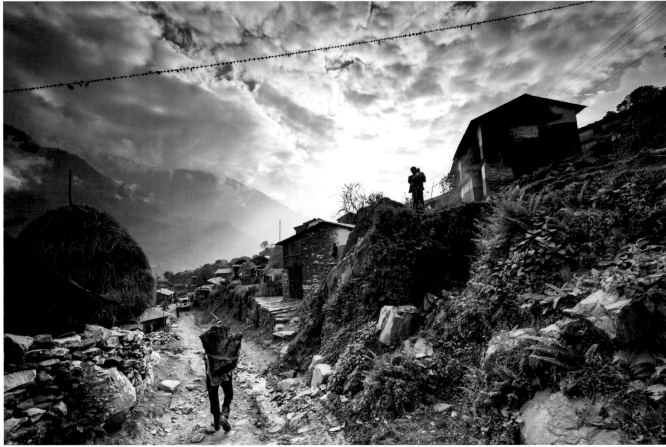

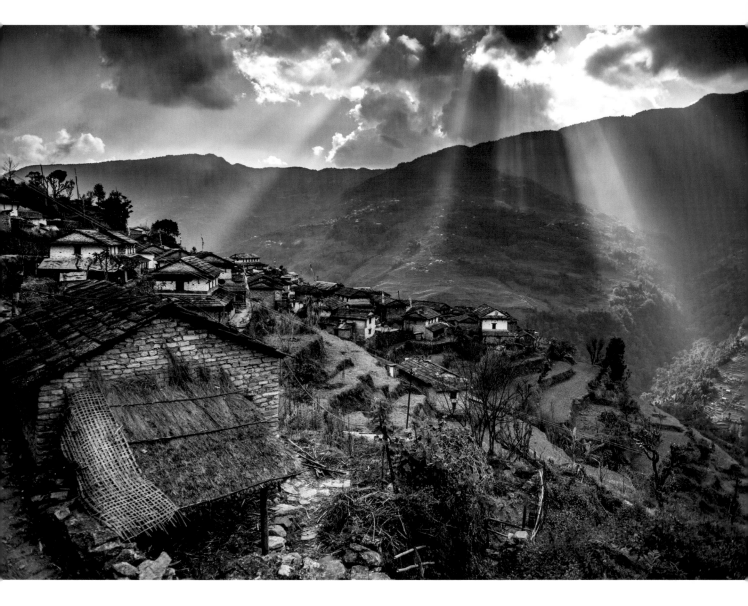

ABOVE: *Sabet, West Nepal, February 2015*

TOP LEFT: *Although there are more and more driveable roads in Nepal, the main road for those living in remote areas are still paths like this*

BOTTOM LEFT: *Life in the Middle Hills*

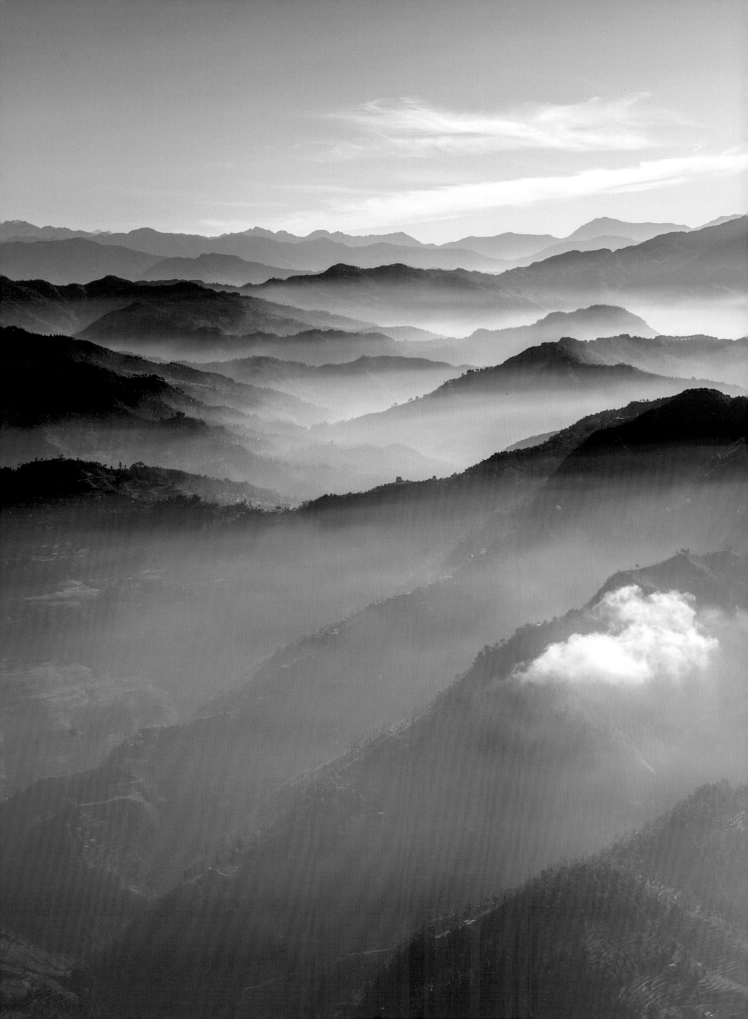

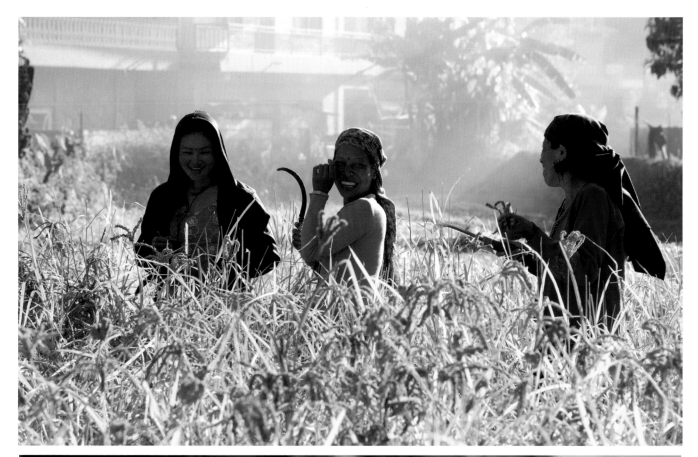

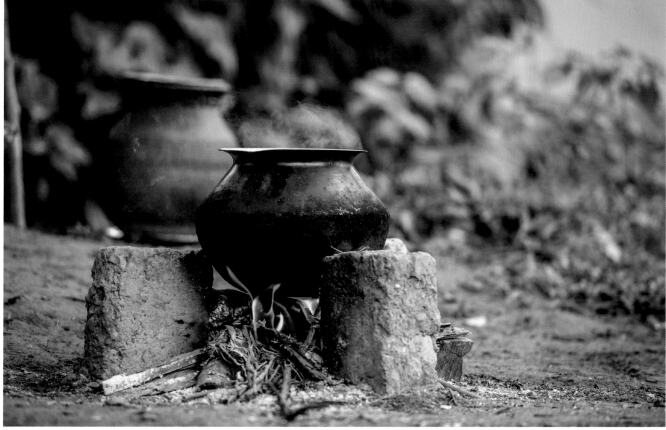

ABOVE: *Cutting millet*

BELOW: *Boiling rice for the daily dal baht*

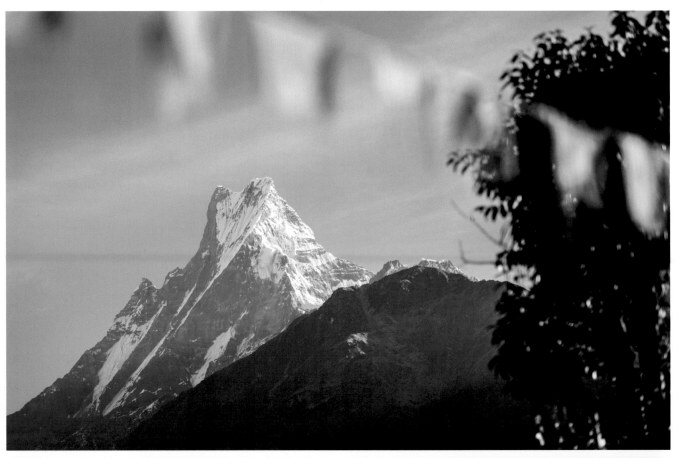

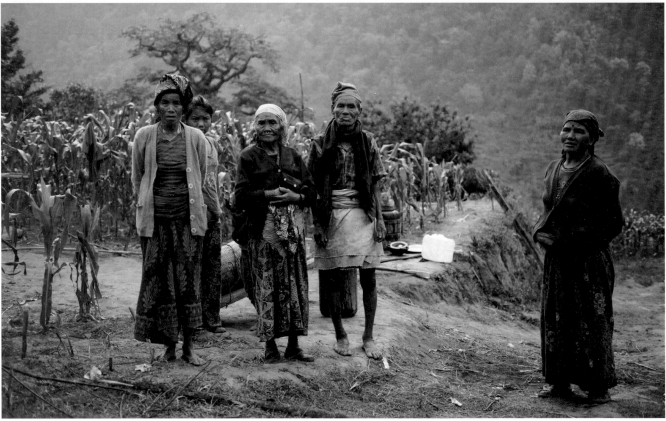

ABOVE: *Machhapuchhre or "Fishtail"*
BELOW: *People still live a very basic, subsistence life in the Middle Hills of Nepal*

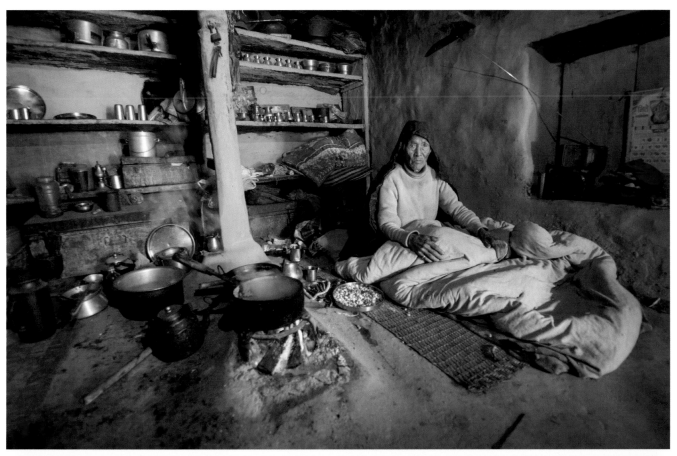

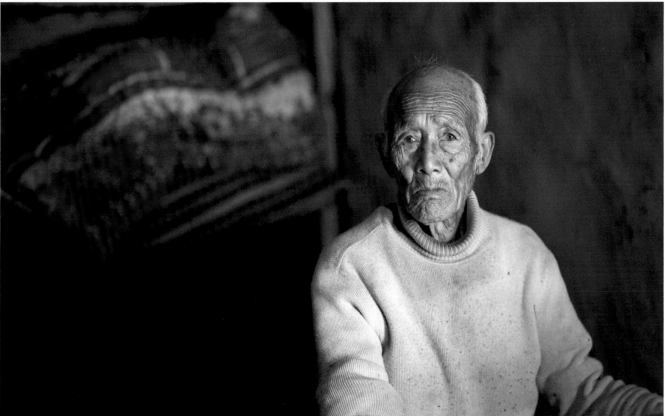

This elderly former Gurkha from the Second World War is bedridden

He sleeps next to the cooking fire for warmth despite the harm the smoke does to the lungs

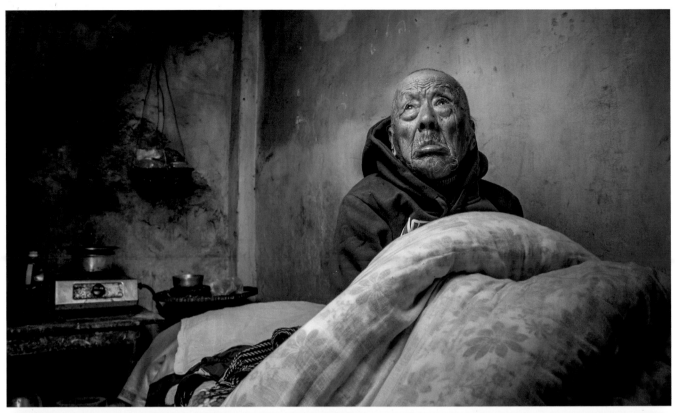

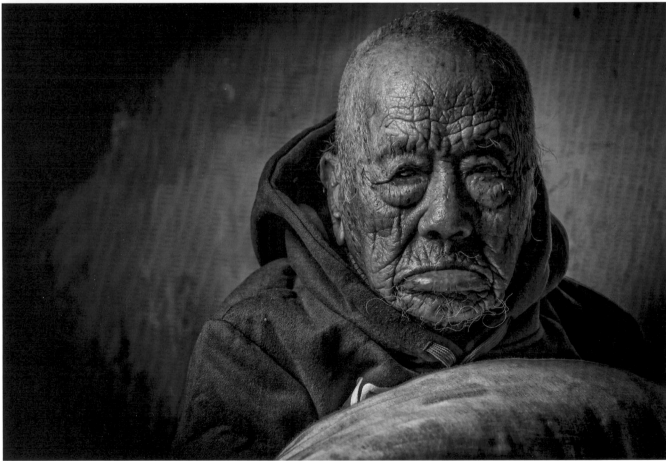

This ex-Gurkha told me he was 104 years old. Records show he was only 102!
He survives only because of the welfare pension given to him each month by the Gurkha Welfare Trust

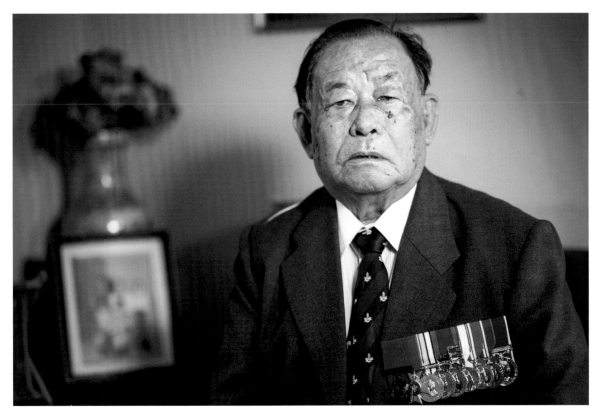

The last surviving Gurkha Victoria Cross winner at home in Kathmandu – Captain Rambahadur Limbu VC

Lance Corporal Rambahadur Limbu, 10th Gurkha Rifles, Borneo – 21 November 1965 (Taken from the *London Gazette* 22 April 1966)

"…Leading his support group in the van of the attack he could see the nearest trench and in it a sentry manning a machine gun. Determined to gain first blood he inched himself forward until… he was seen and the sentry opened fire, immediately wounding a man to his right. Rushing forward he reached the enemy trench… and killed the sentry, thereby gaining for the attacking force a foothold on the objective …with a complete disregard for the hail of fire he got together and led his fire group to a better fire position…

…he saw both men of his own group seriously wounded… and… immediately commenced… to rescue his comrades… he crawled forward, in full view of at least two enemy machine gun posts who concentrated their fire on him… but… was driven back by the accurate and intense… fire… After a pause he started again…

Rushing forward he hurled himself on the ground beside one of the wounded and calling for support from two light machine guns… he picked up the man and carried him to safety… Without hesitation he immediately returned… (for the other) wounded man (and) carried him back… through the hail of enemy bullets. It had taken twenty minutes to complete this gallant action and the events leading up to it. For all but a few seconds this Non-Commissioned Officer had been moving alone in full view of the enemy and under the continuous aimed fire of their automatic weapons. …His outstanding personal bravery, selfless conduct, complete contempt of the enemy and determination to save the lives of the men of his fire group set an incomparable example and inspired all who saw him.

Finally, Lance Corporal Rambahadur was responsible for killing four more enemy as they attempted to escape."

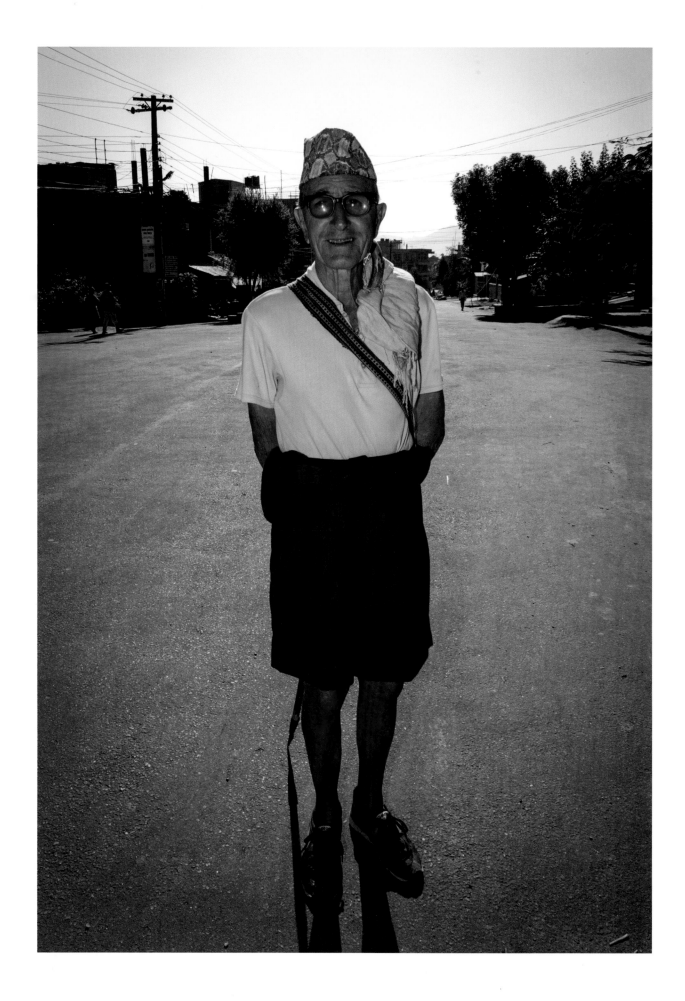

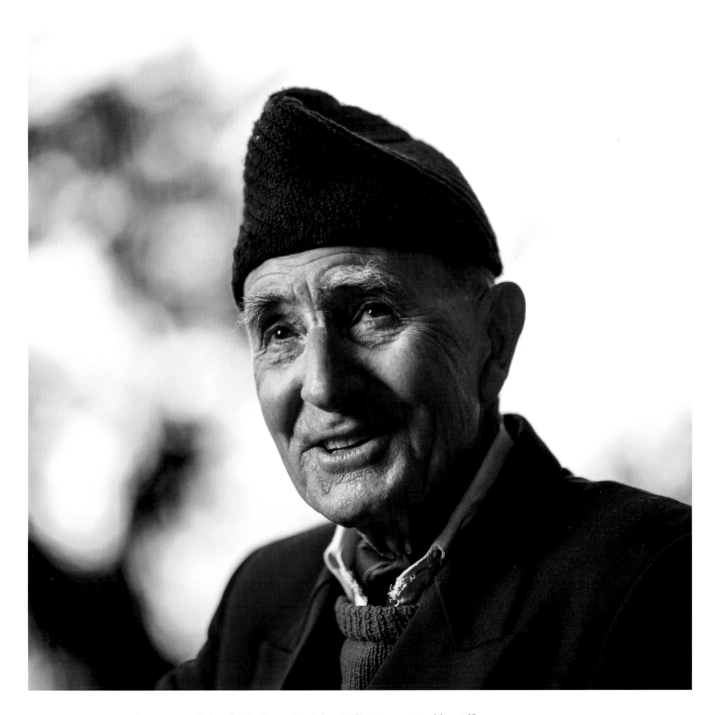

LEFT AND ABOVE: *Lieutenant Colonel J P Cross OBE (or JPX). Former Gurkha Officer, who served in the British Army from 1943–1982, now author and second ever Briton to become a citizen of Nepal. Bilingual and to many Gurkha soldiers, their "Grandfather"*

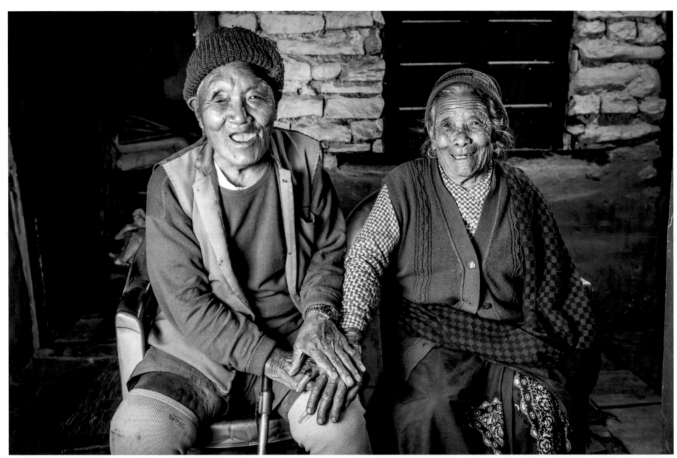

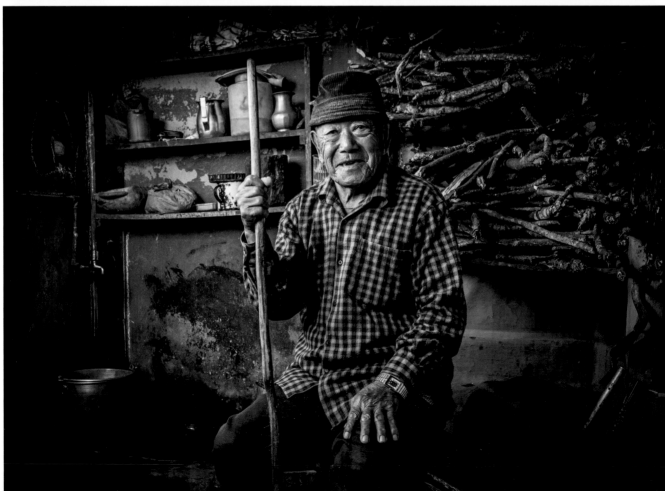

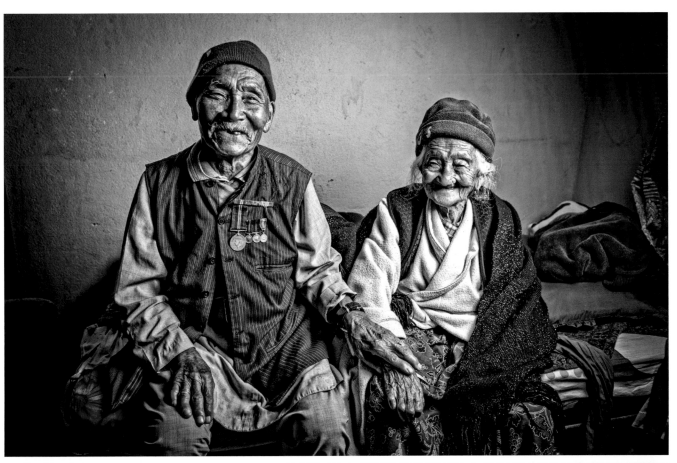

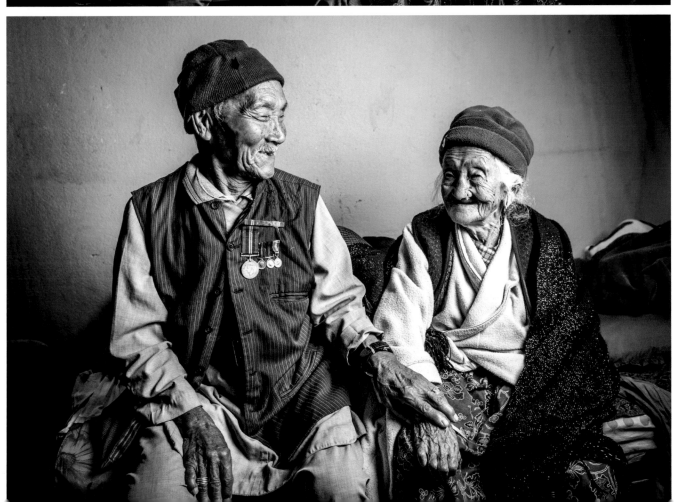

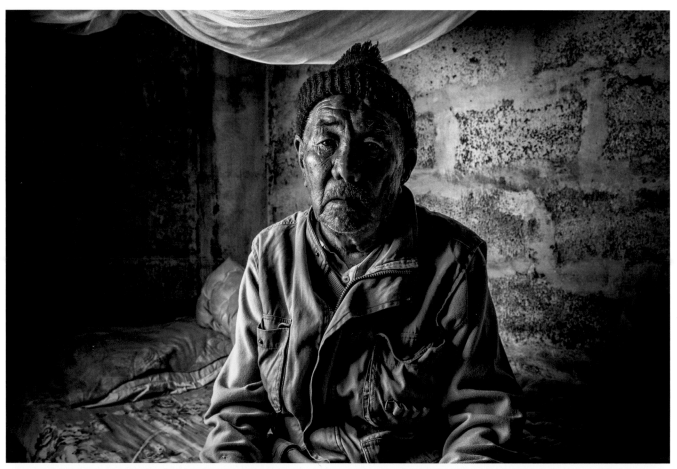

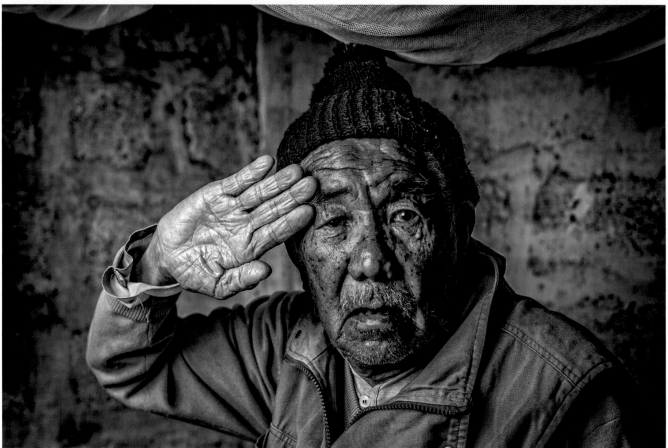

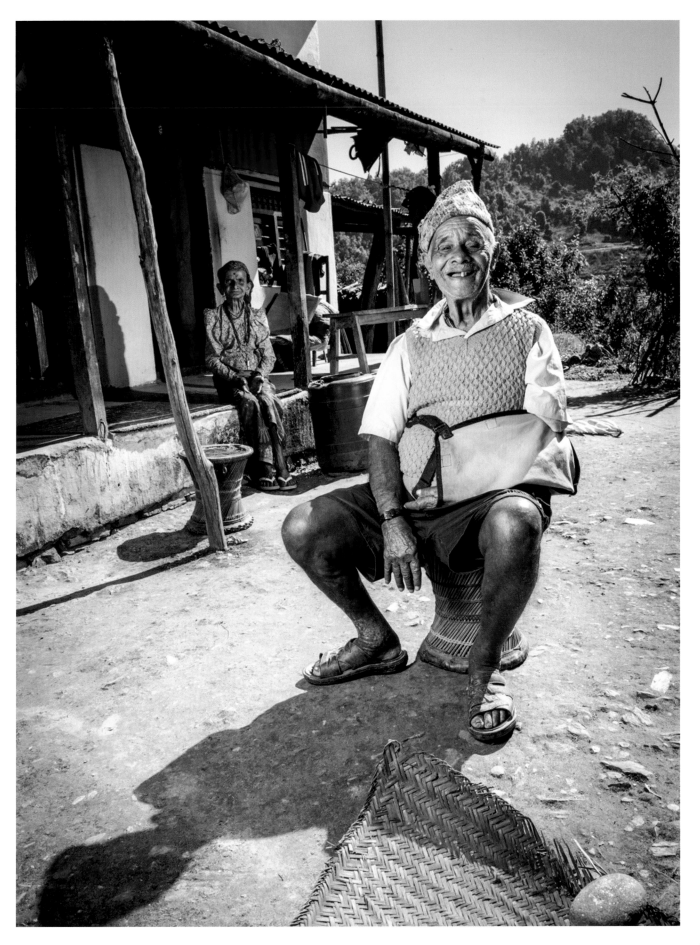

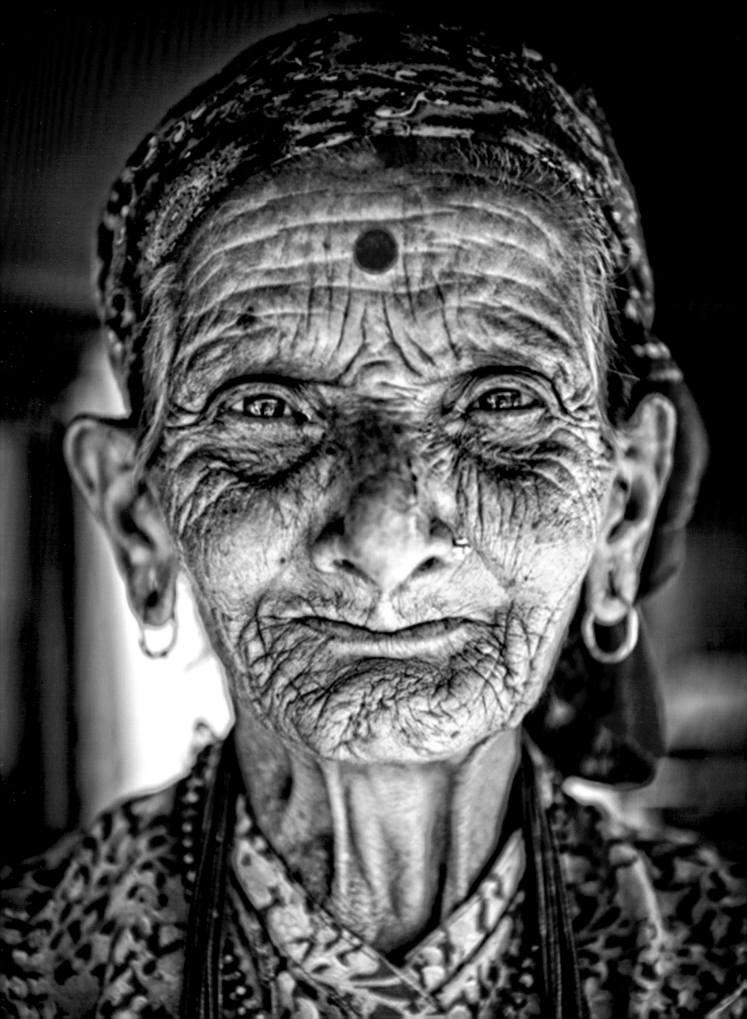

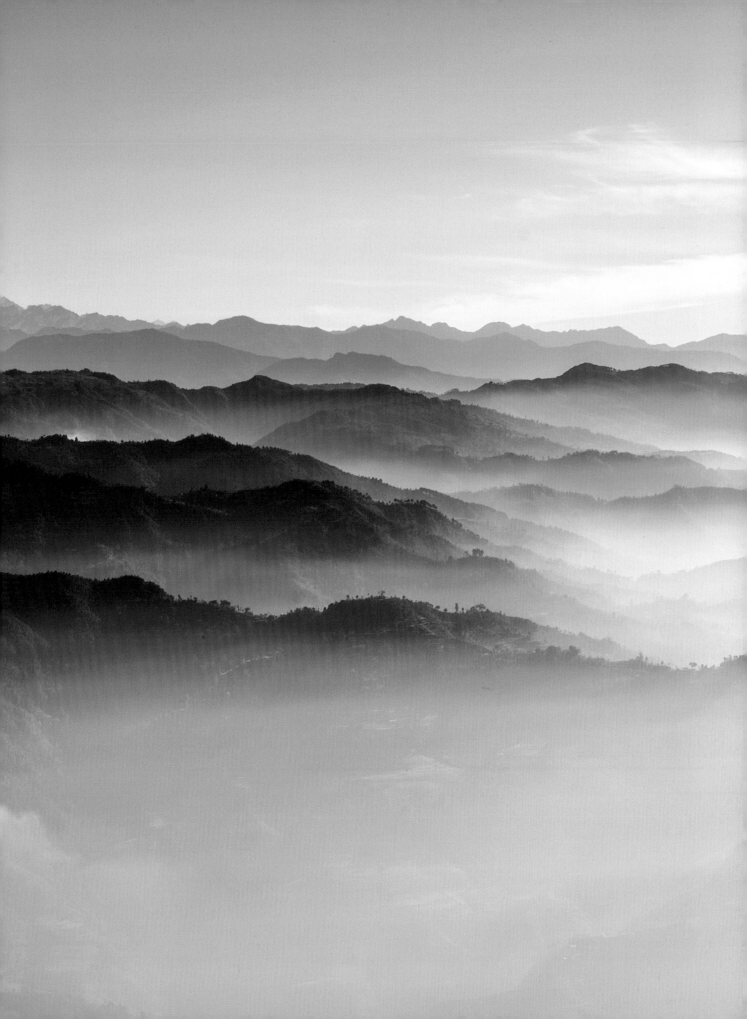

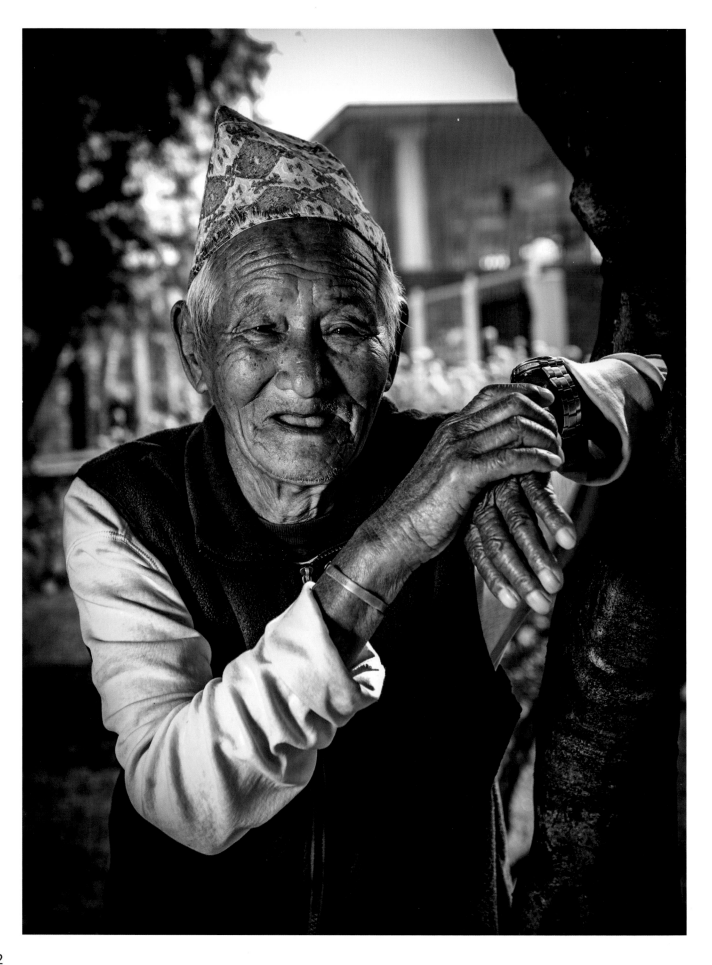

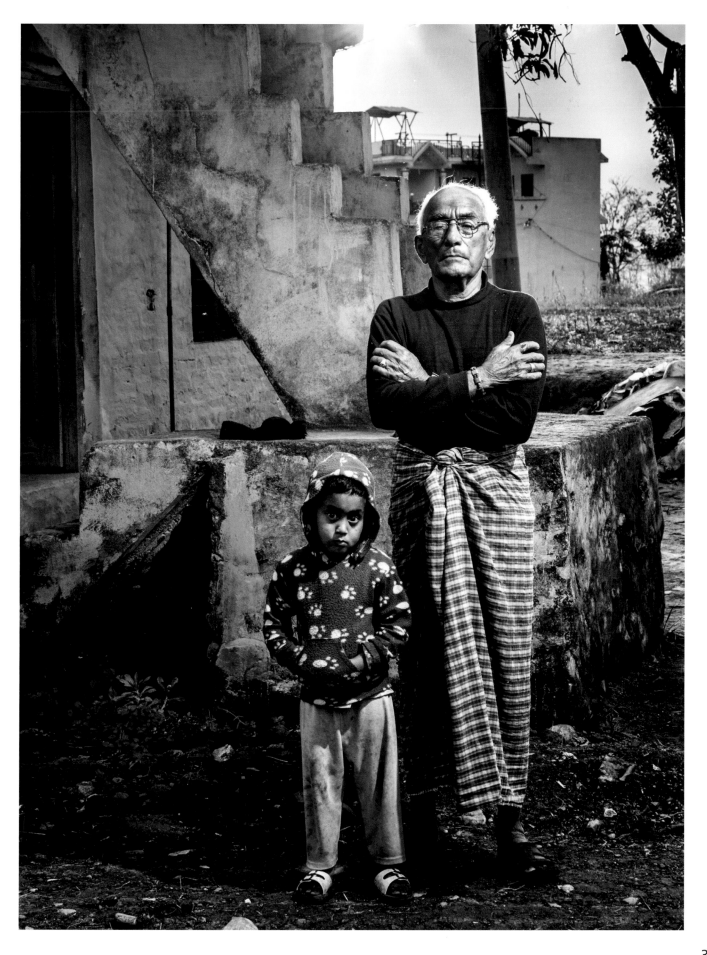

Gurkha Memorial, Darjeeling, September 2011

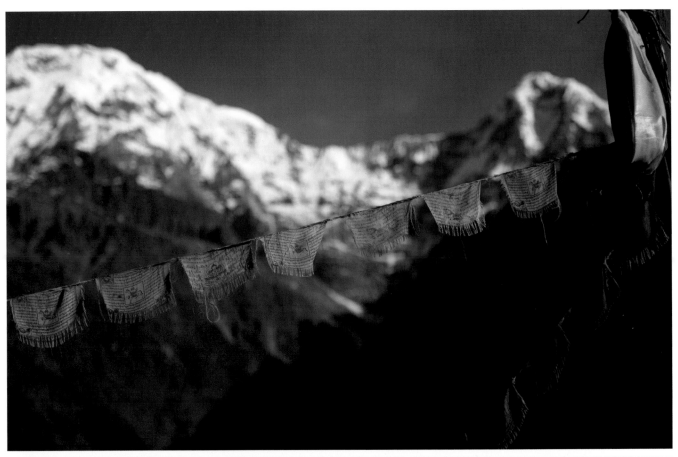

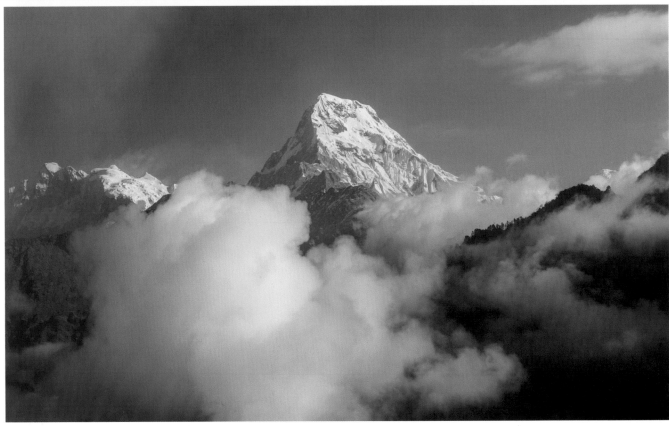

ABOVE: *Prayer Flags, Annapurna, West Nepal, December 2014*

BELOW: *Dhaulagiri (8,167 metres), West Nepal*

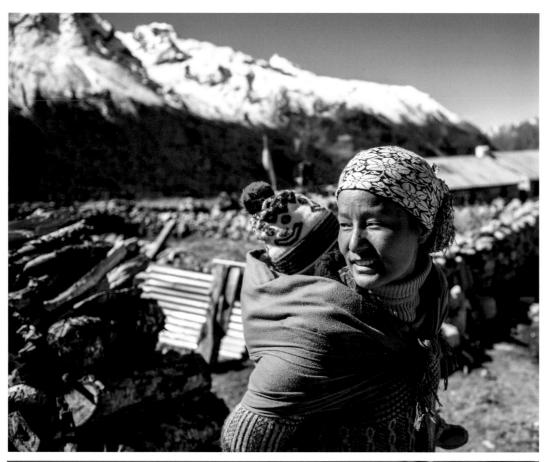

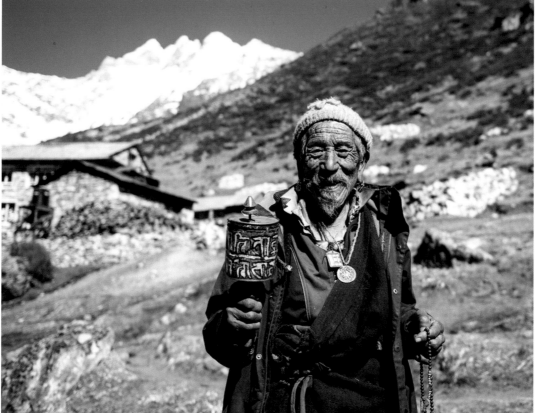

These images were taken in Langtang in November 2014. The villages in the Langtang area were almost completely destroyed in the earthquake just 5 months later. BOTTOM: 92-year-old Lama in Langtang

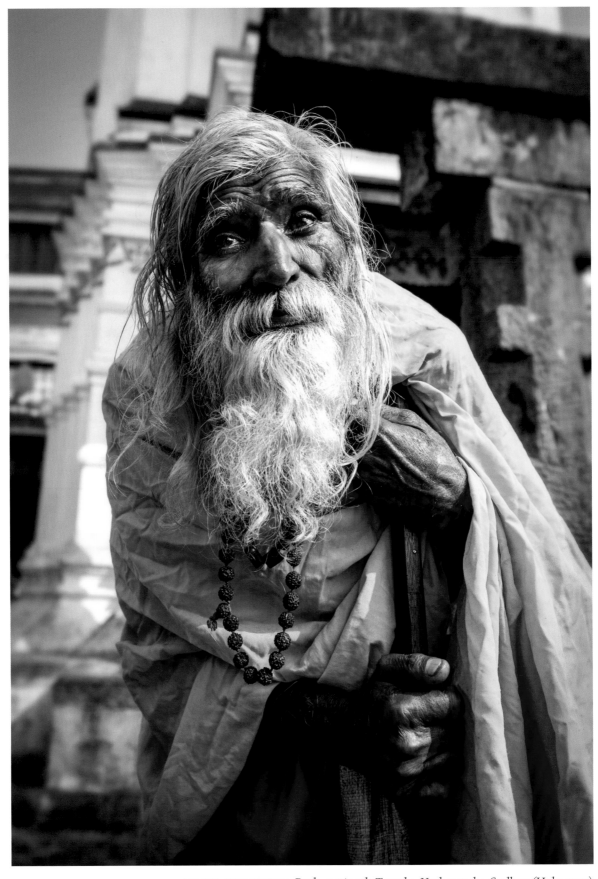

ABOVE AND RIGHT: *Pashupatinath Temple, Kathmandu. Sadhus (Holy-men),*
November 2012

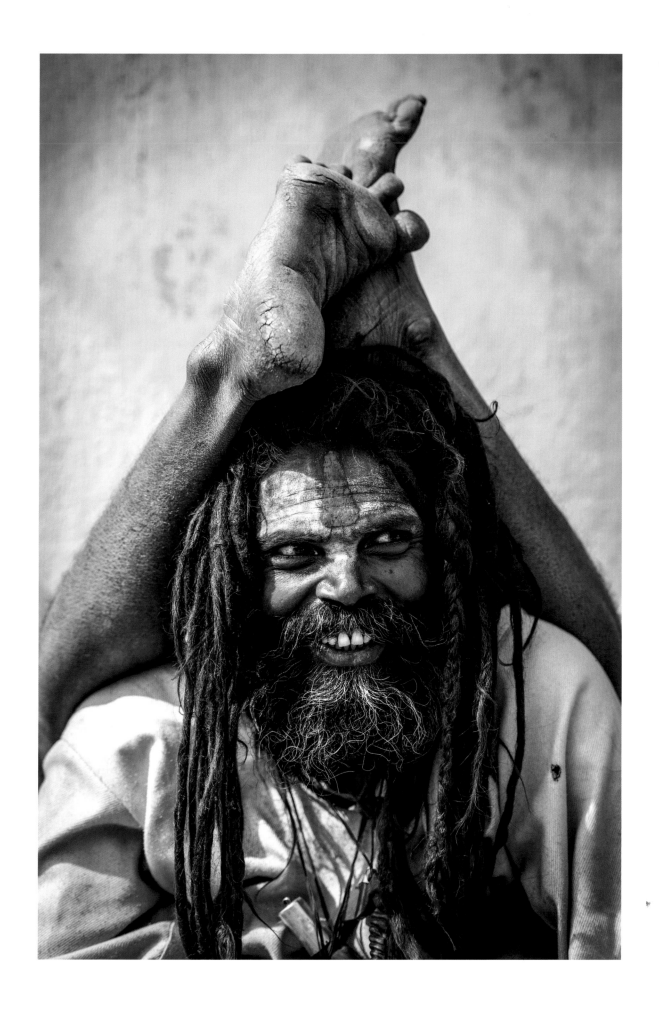

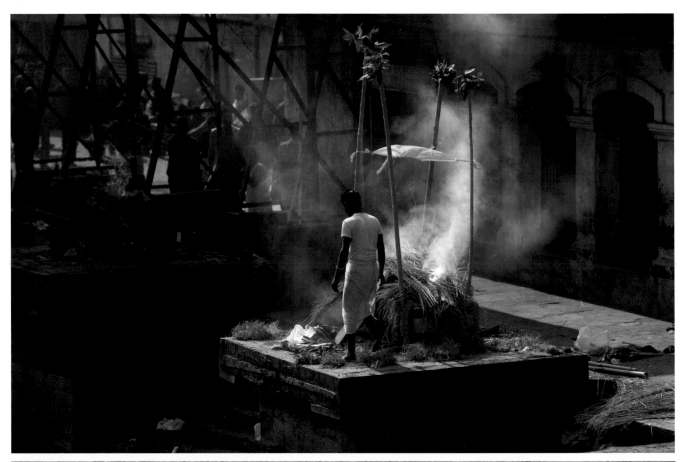

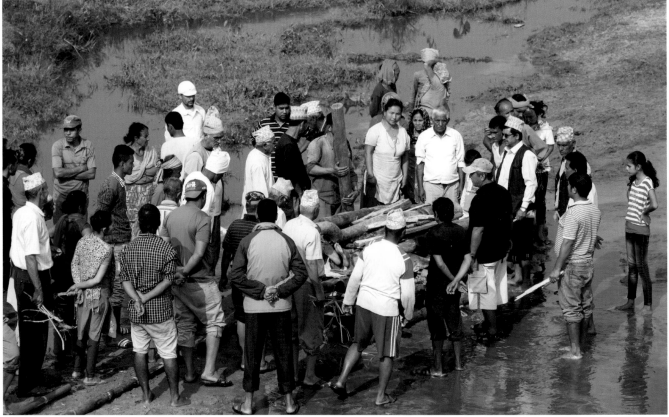

ABOVE: *Hindu cremation, Pashupatinath, November 2012*

BELOW: *Village cremation, Damak, November 2014*

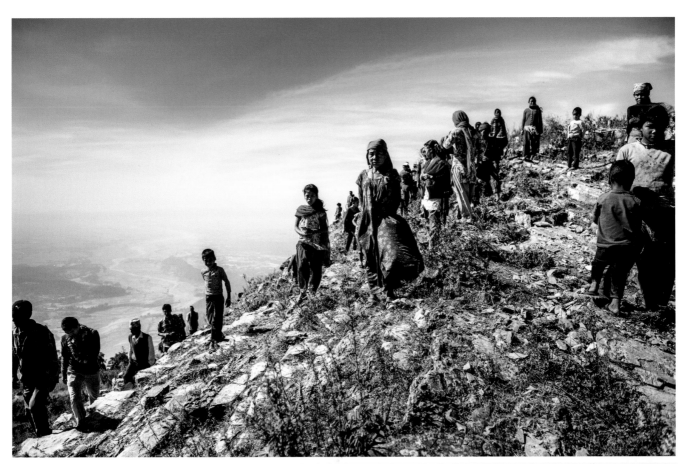

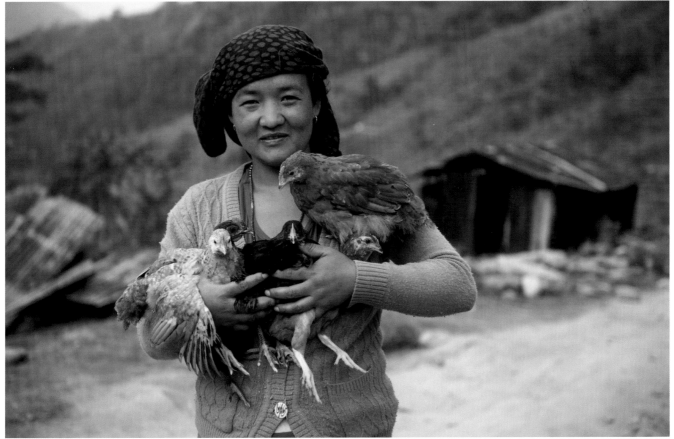

ABOVE: *Village gathering; the hills to the north of the Terai, West Nepal, November 2014*

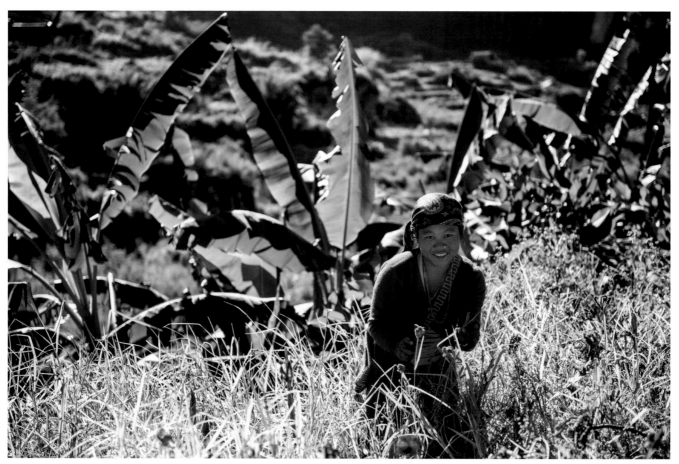

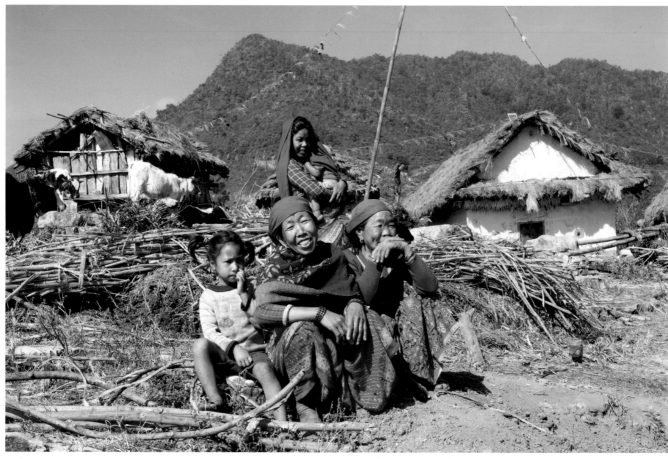

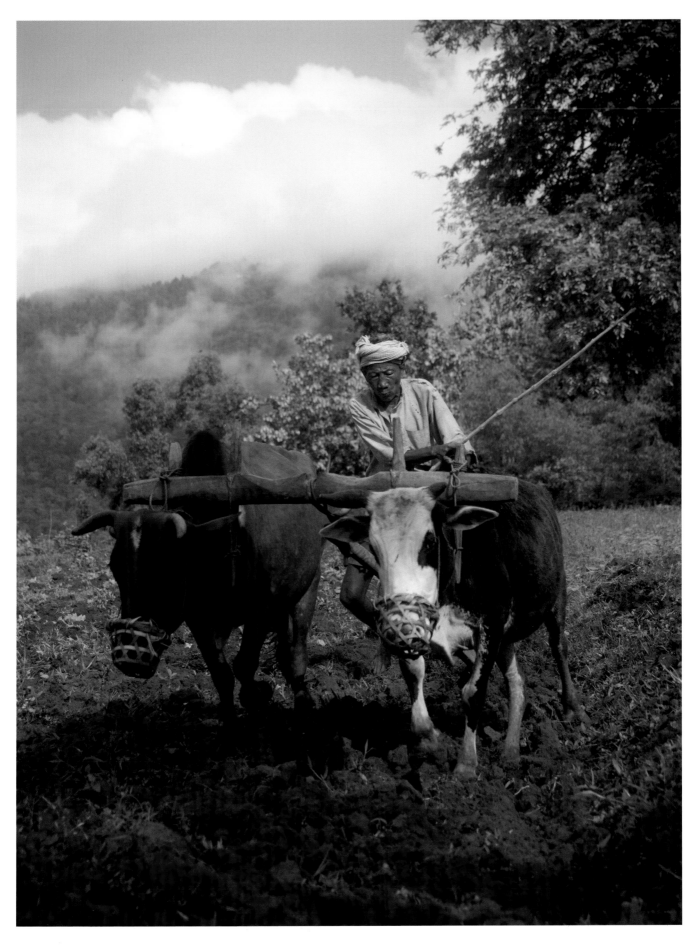

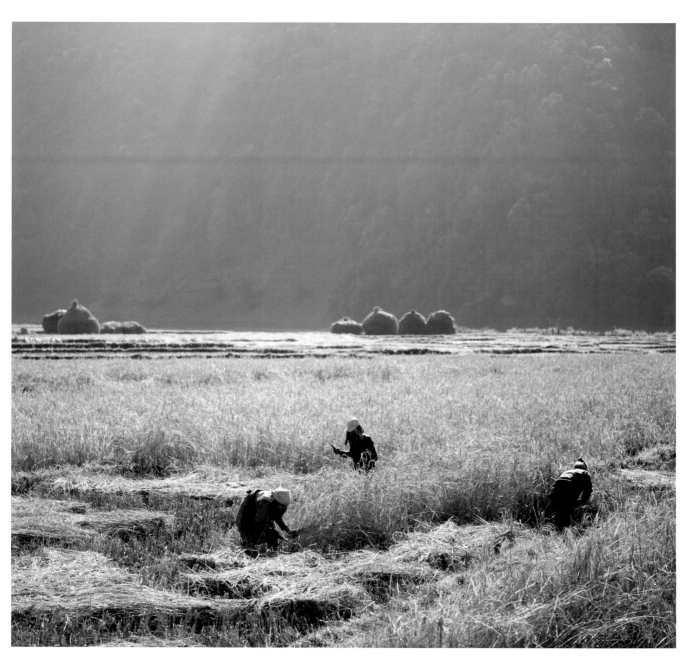

Cutting rice, Badam Valley, Kaski, February 2013

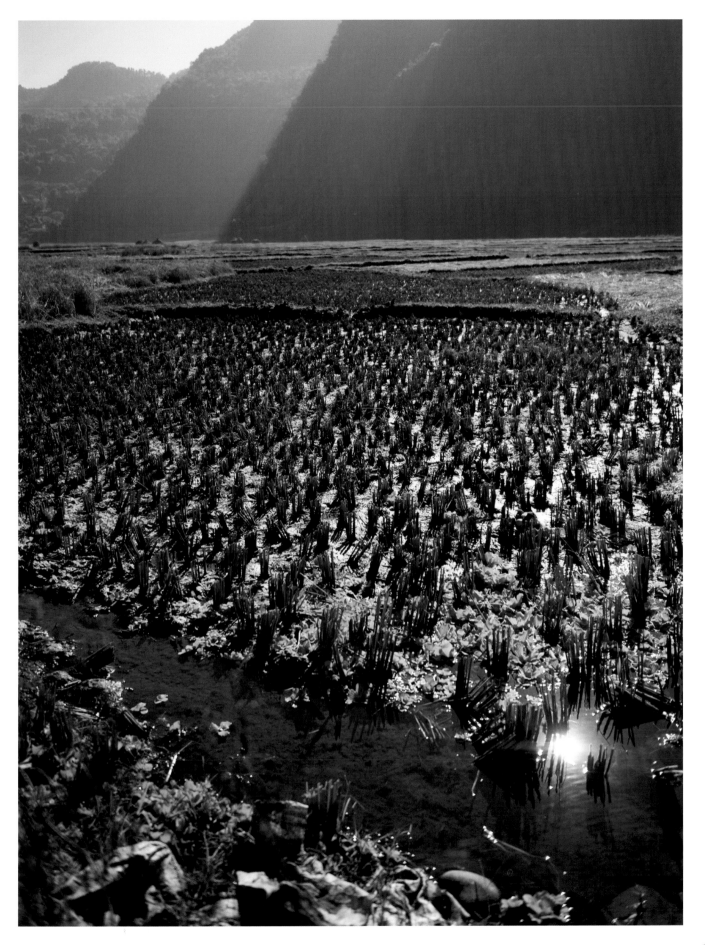

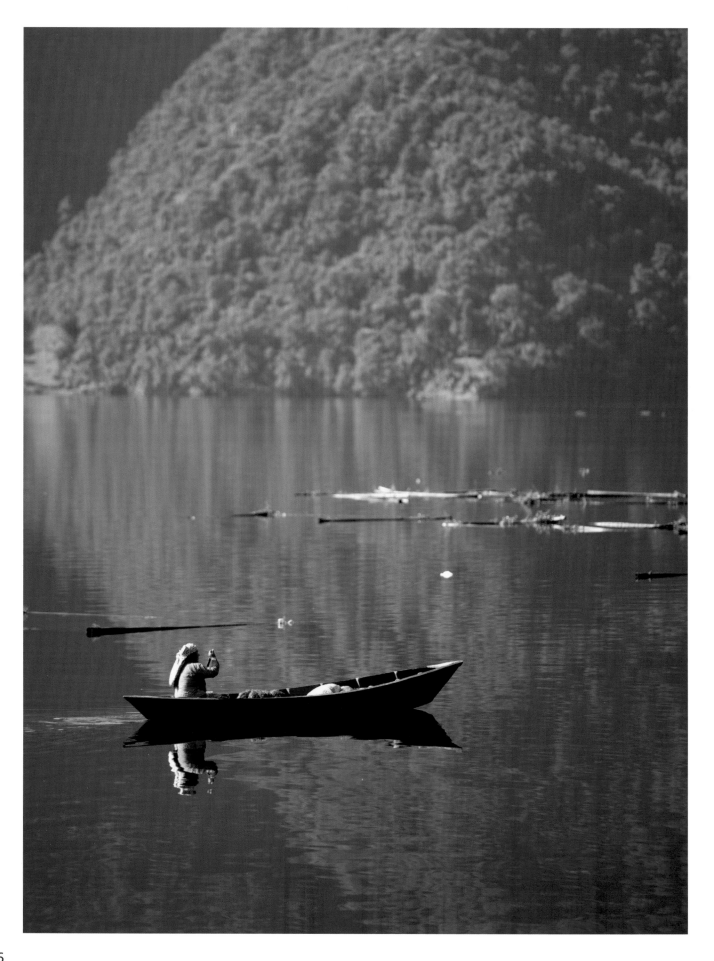

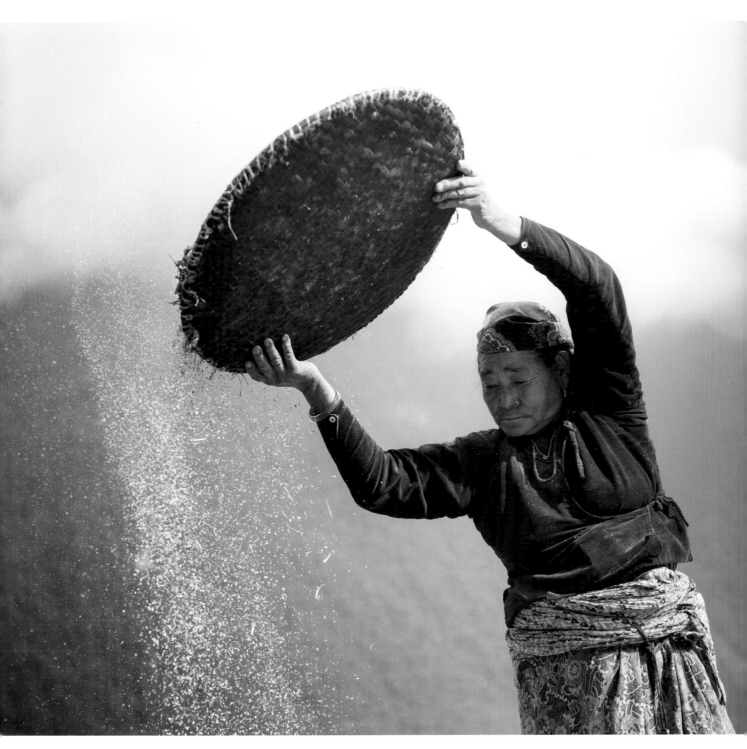

ABOVE: *Separating the "chaff", November 2014*
LEFT: *Transporting vegetables, Fewa Lake, Pokhara, October 2011*

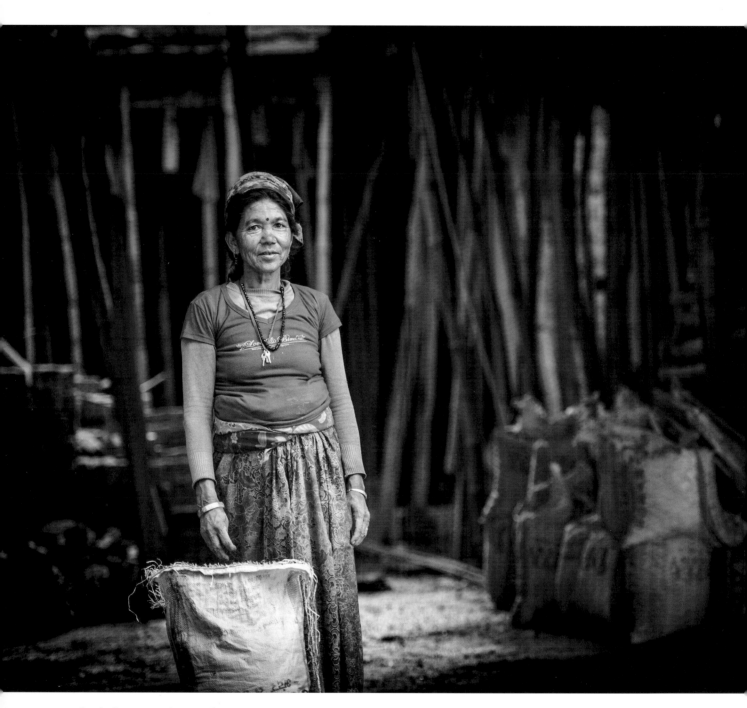

This lady was working on her own, carrying very heavy hand-filled bags of cement. Baglung, West Nepal, November 2014

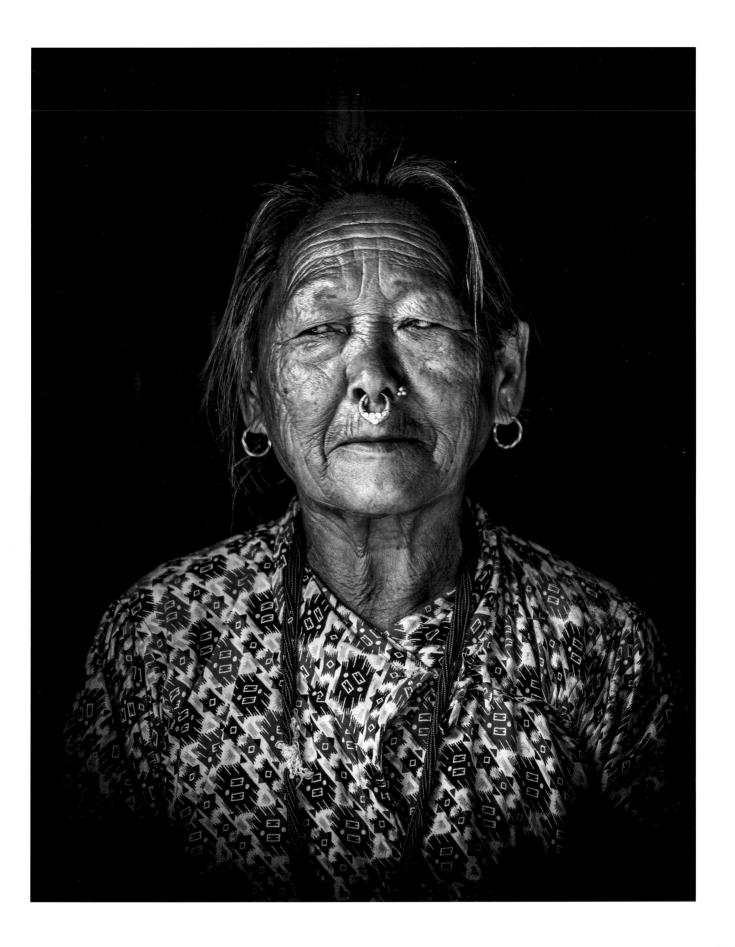

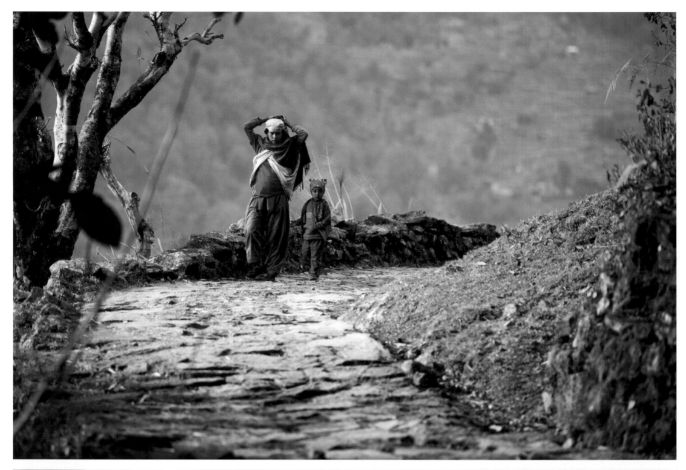

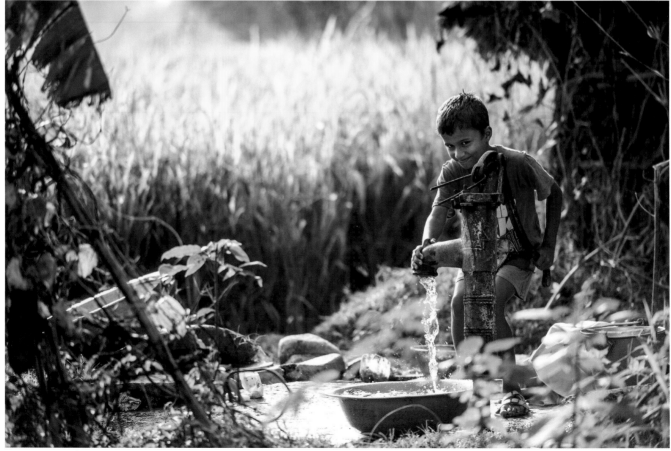

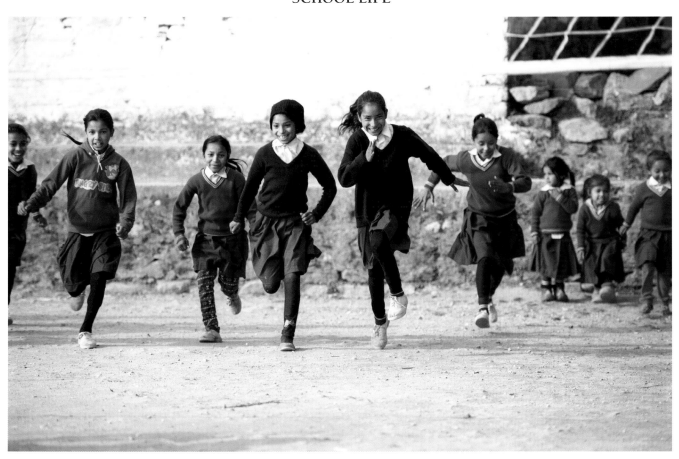

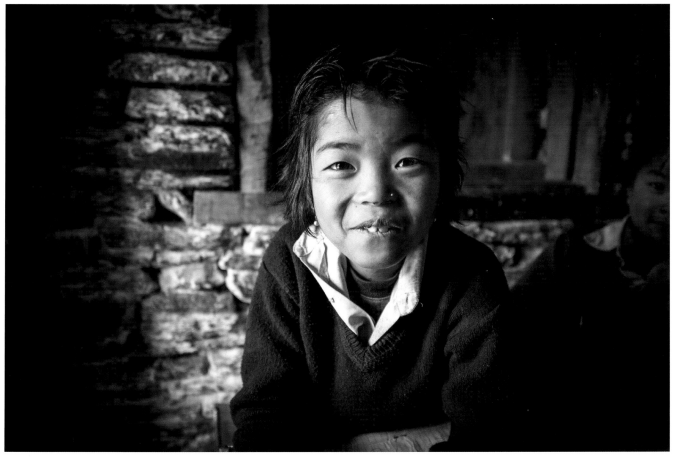

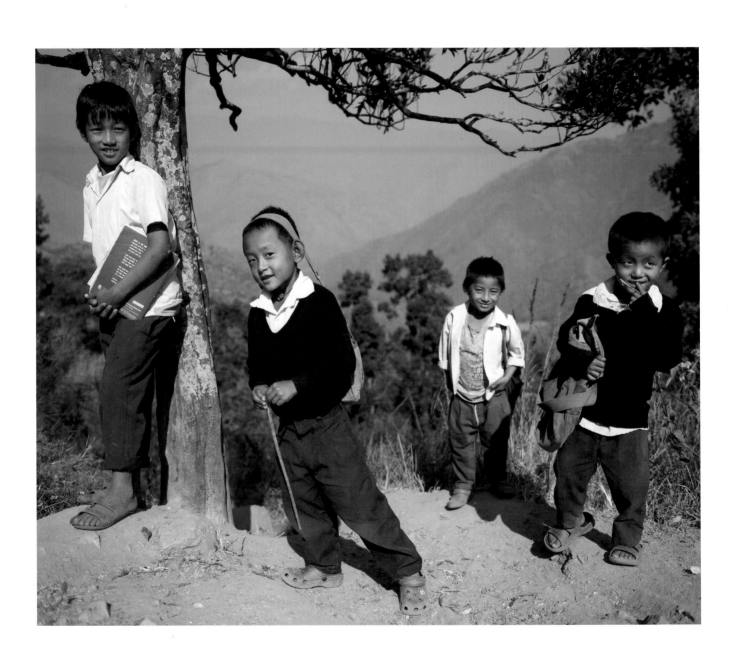

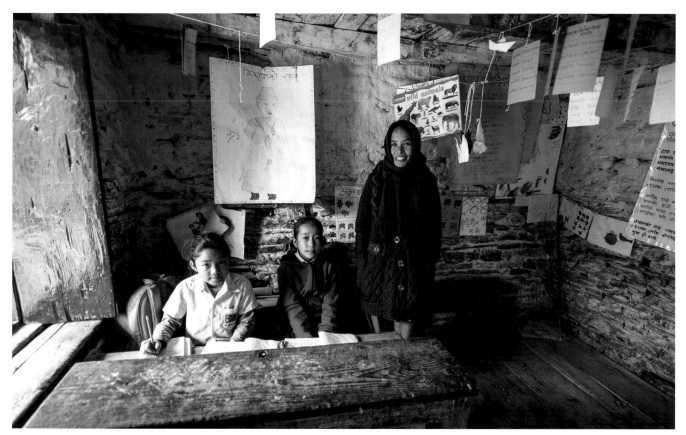

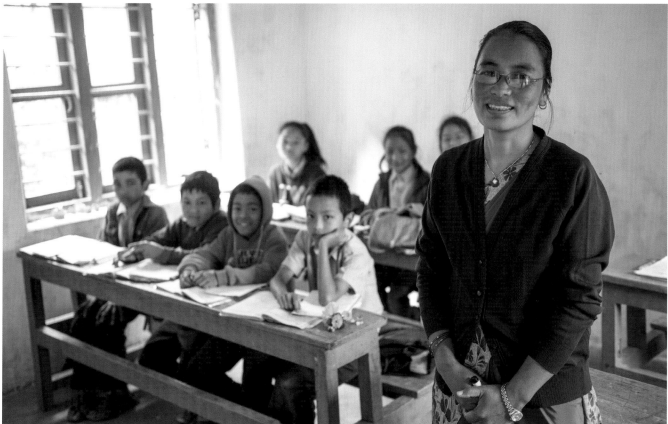

ABOVE: *Remote village school*
BELOW: *School in Tiplyang, West Nepal, built by the Gurkha Welfare Trust and completed in 2012. Opened by Joanna Lumley*

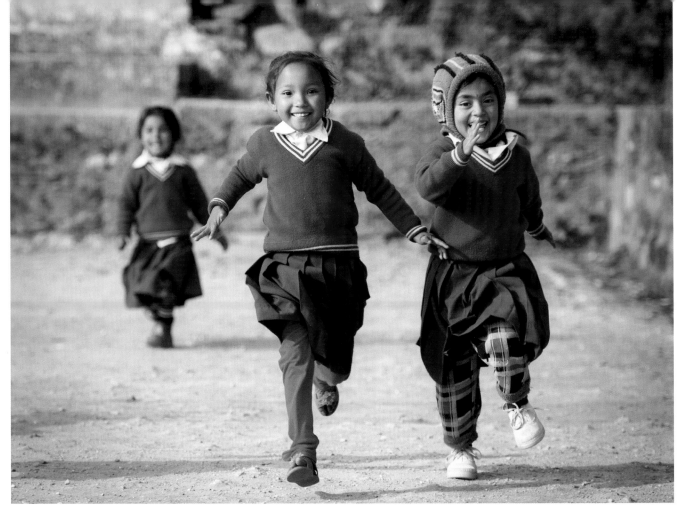

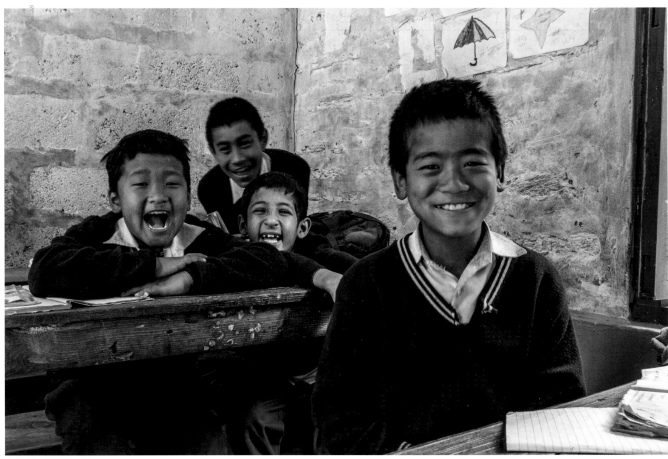

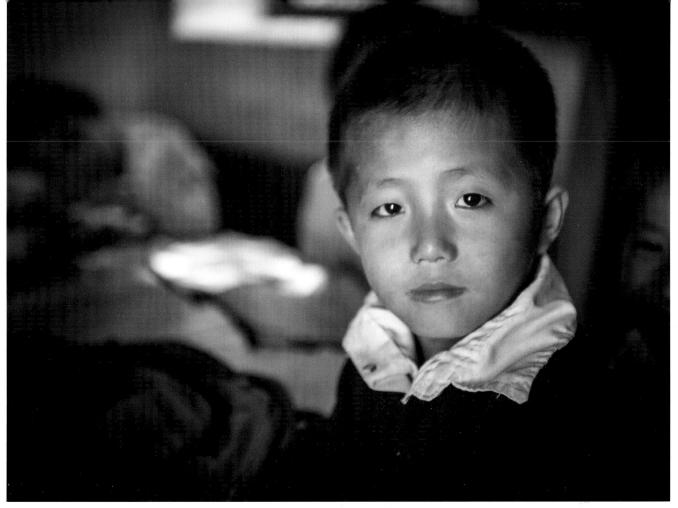

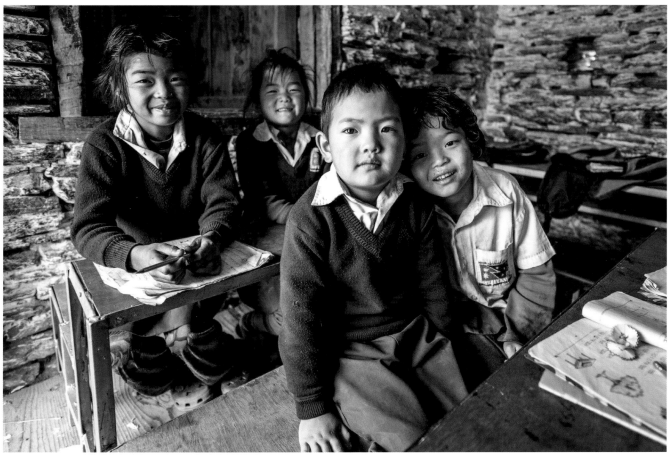

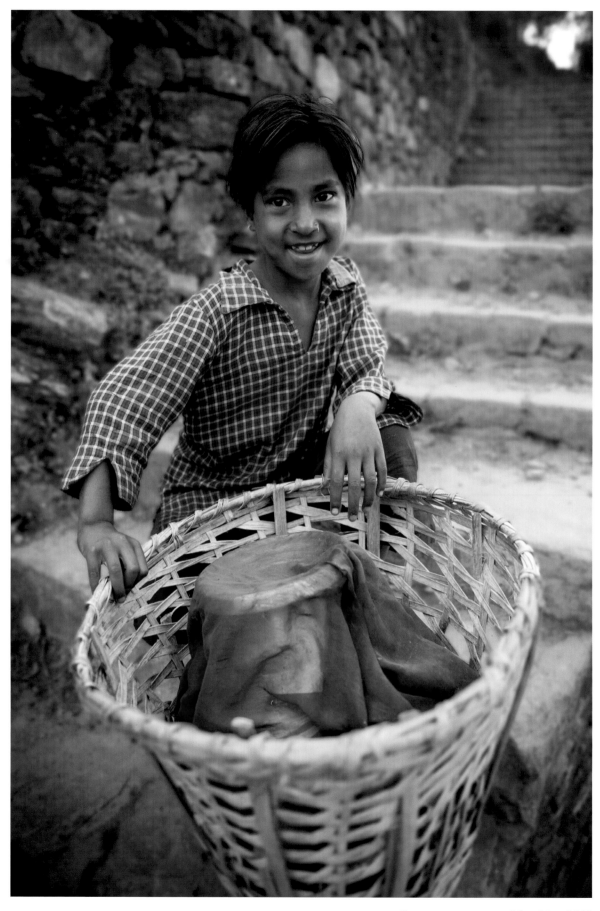

Carrying water in a doko, May 2012

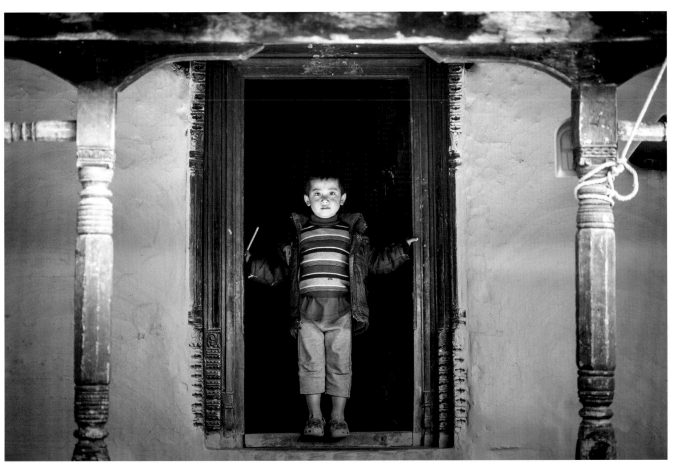

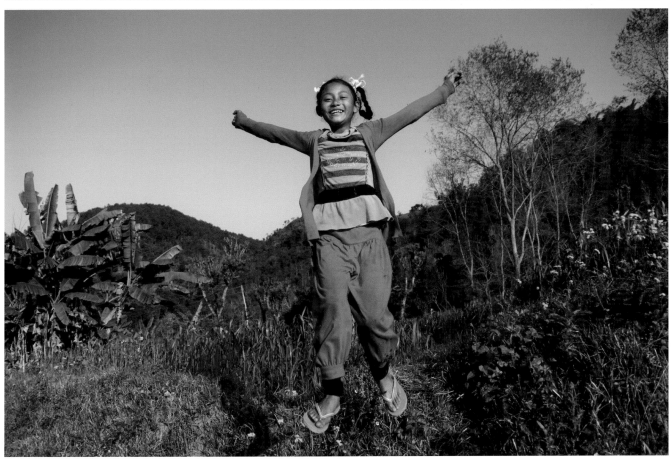

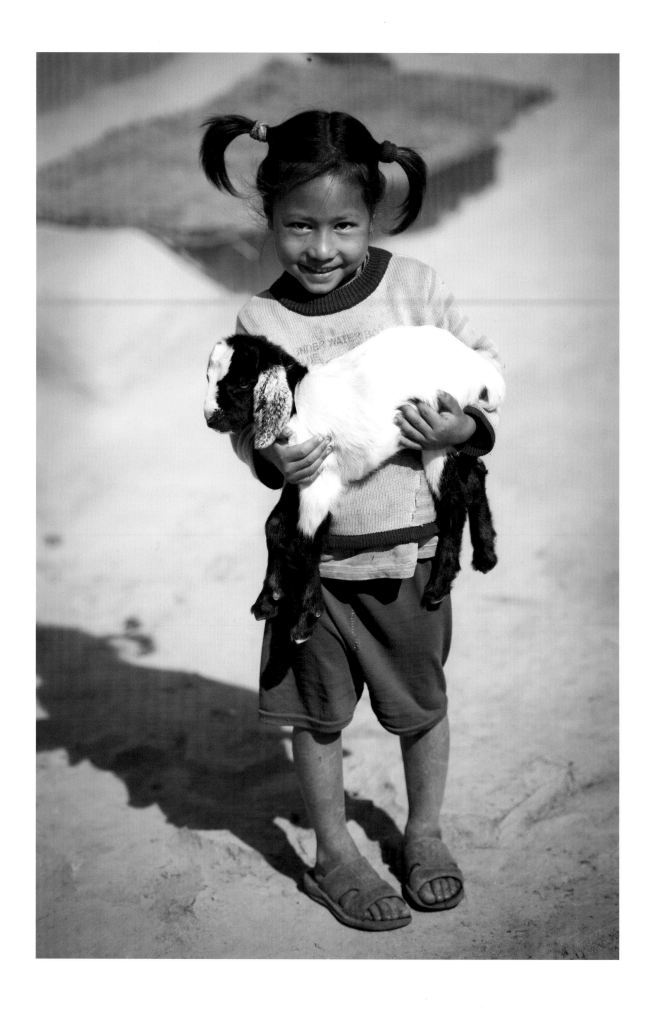

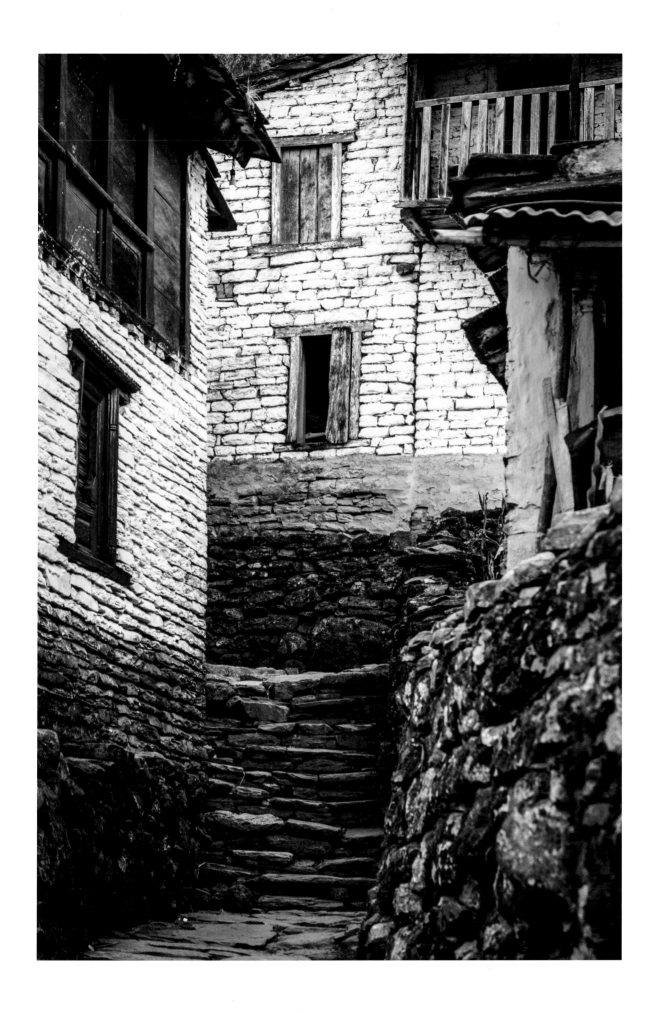

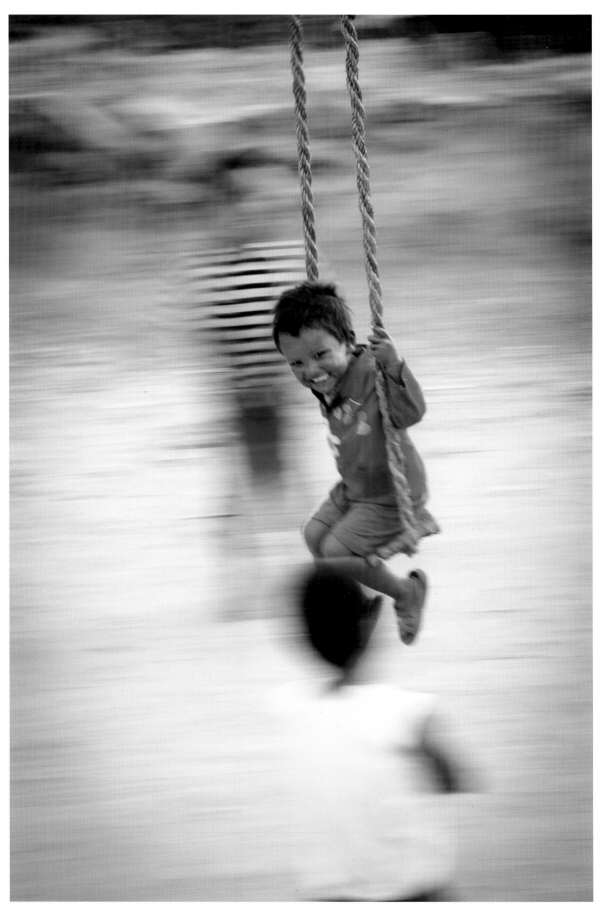

The "Ping Swing" during Dashain, Gorkha, West Nepal, November 2012

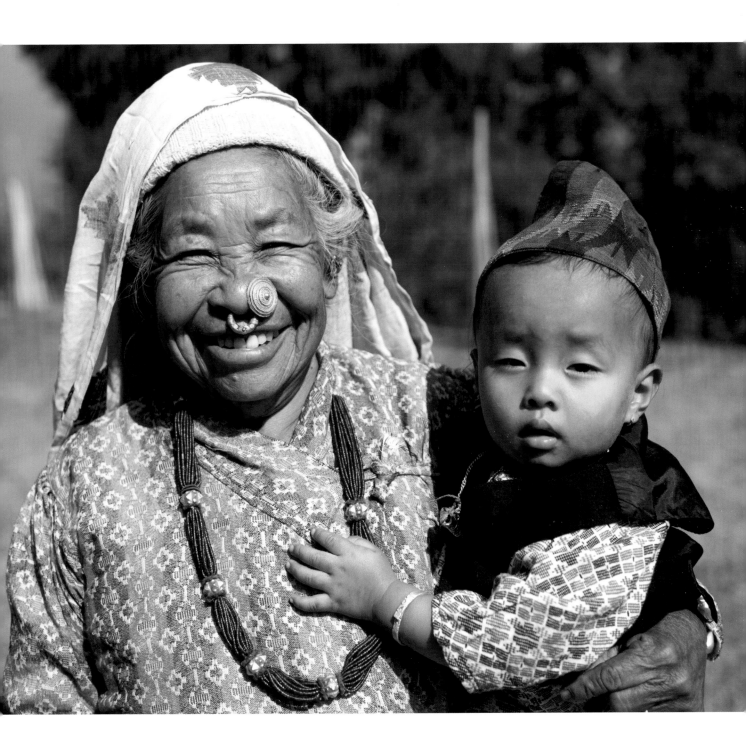

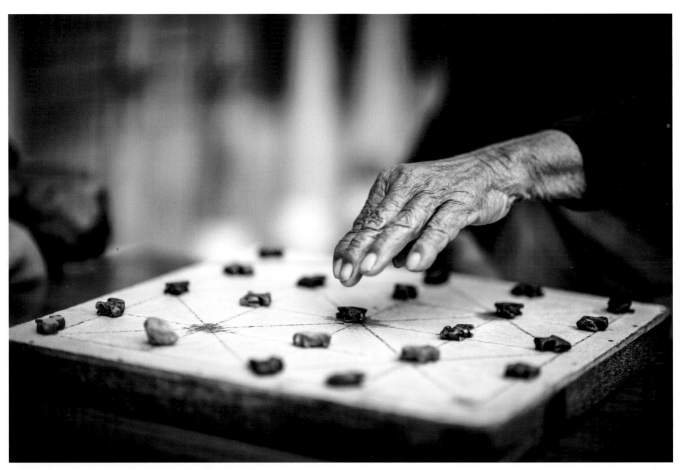

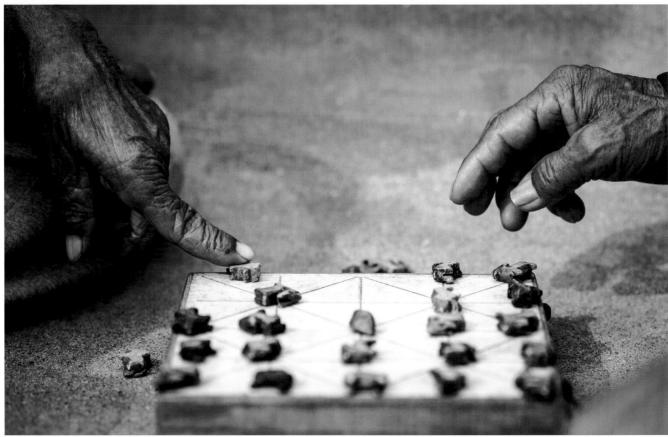

Bhag-Chal, or Tigers versus Goats, Kaski, December 2014

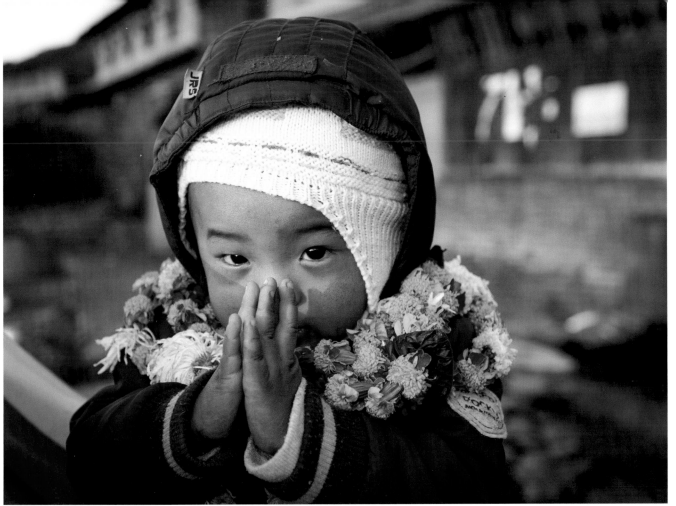

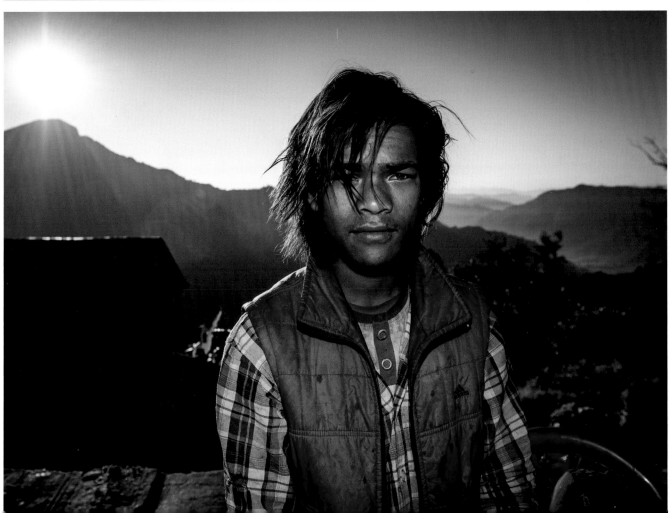

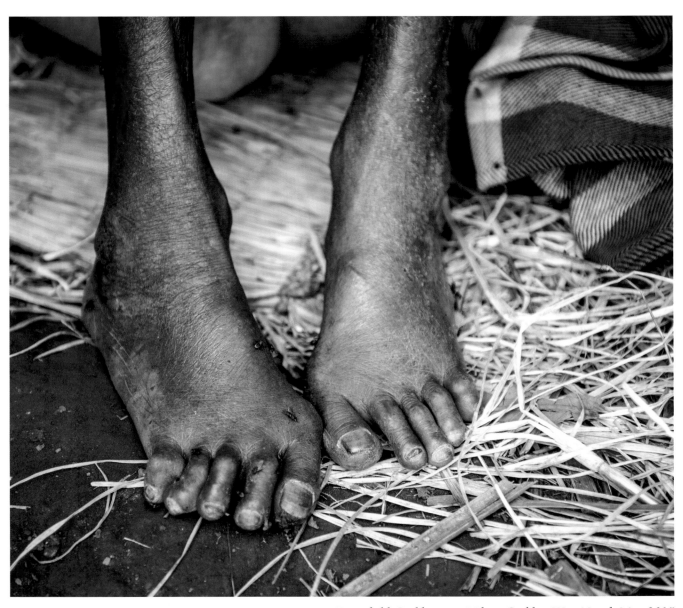

Feet of old Gurkha near Milim, Gorkha, West Nepal, May 2015

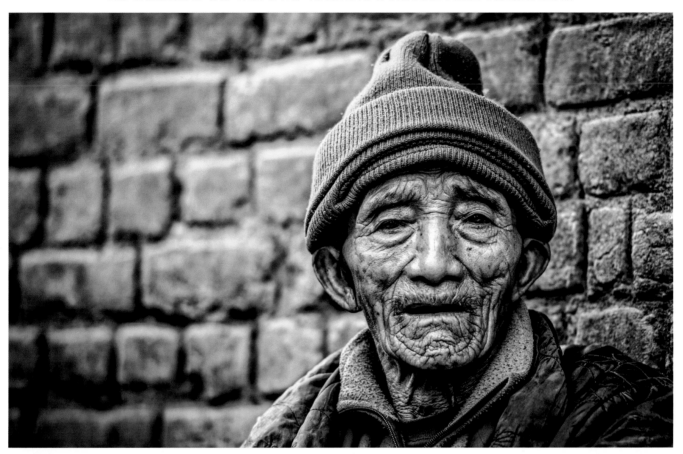

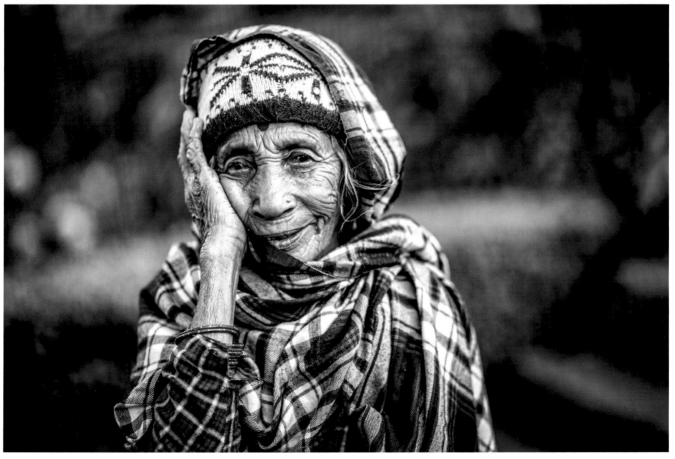

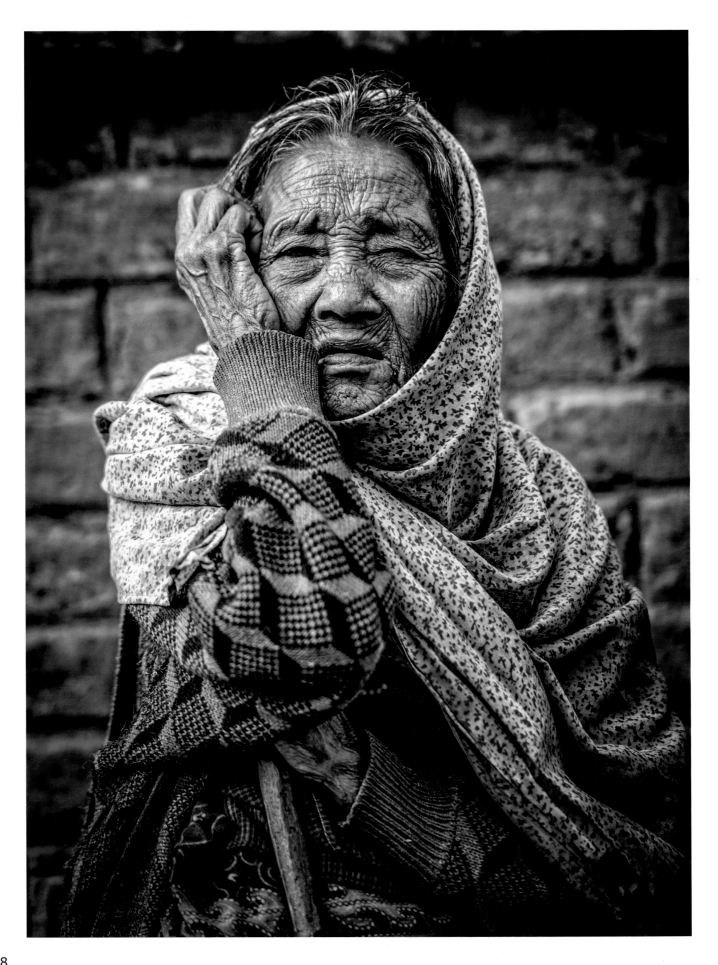

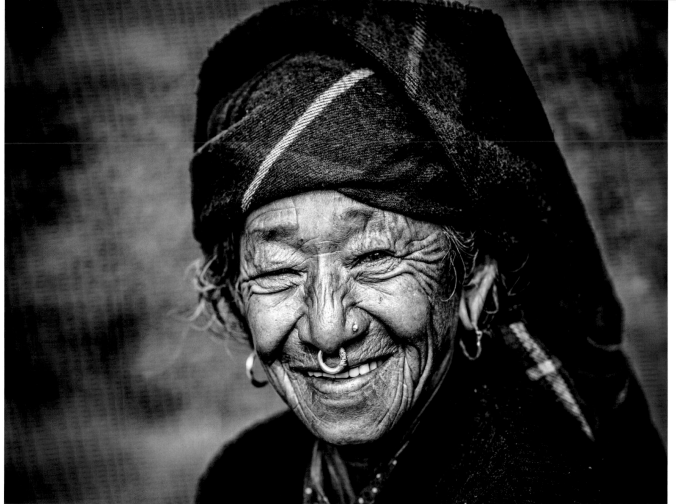

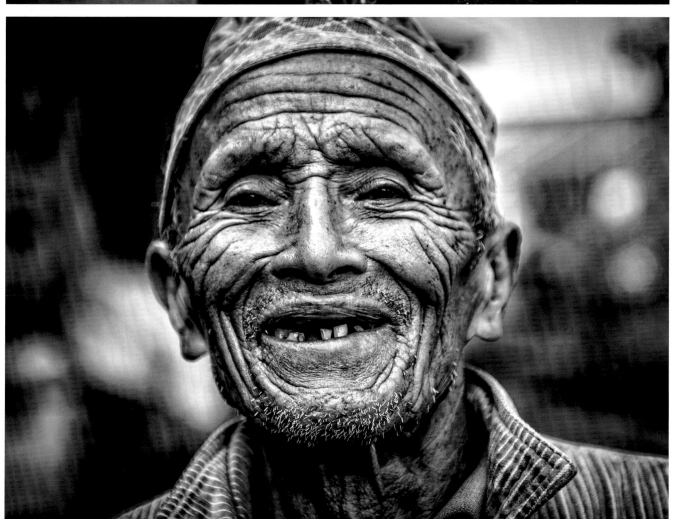

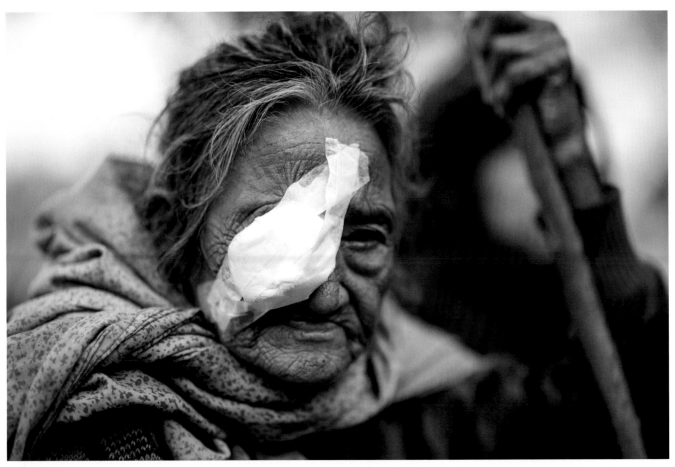

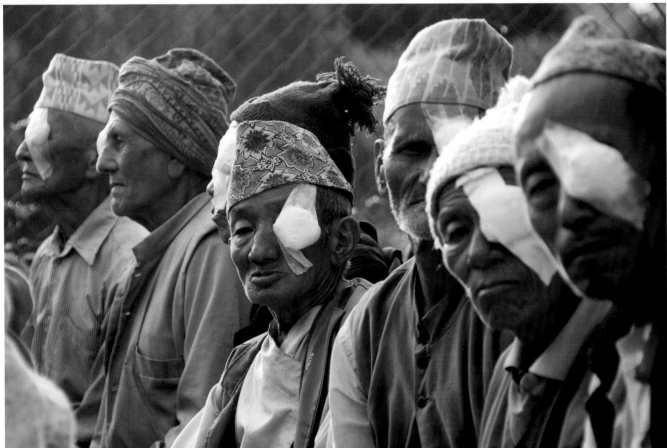

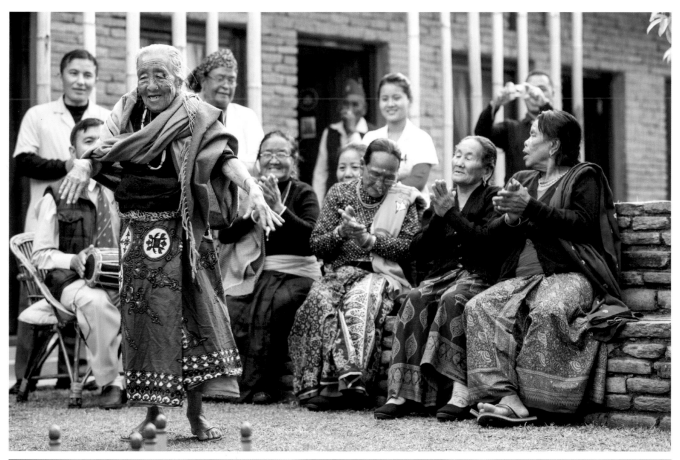

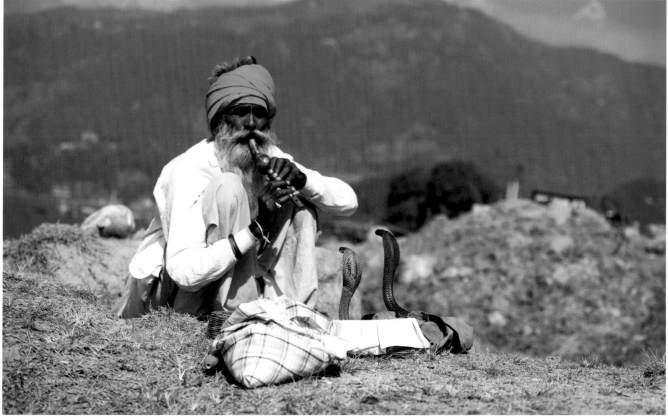

ABOVE: *Gurkha Welfare Trust residential home residents, Pokhara, West Nepal, December 2014*

BELOW: *Snake Charmer, Pokhara, February 2012*

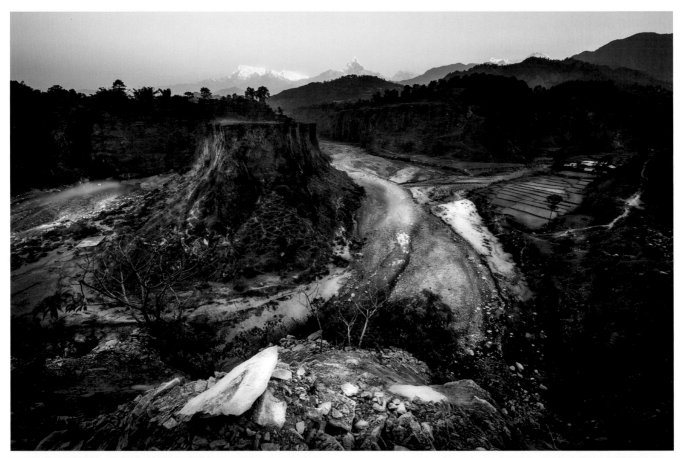

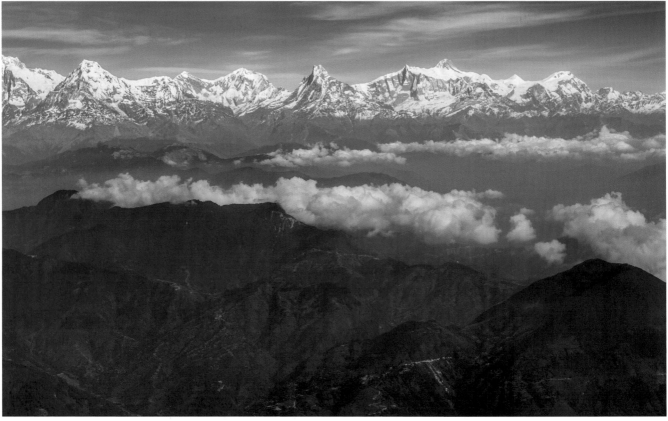

ABOVE: *KaliKhola valley with the Annapurna range behind*

BELOW: *Everest Region, East Nepal, December 2014*

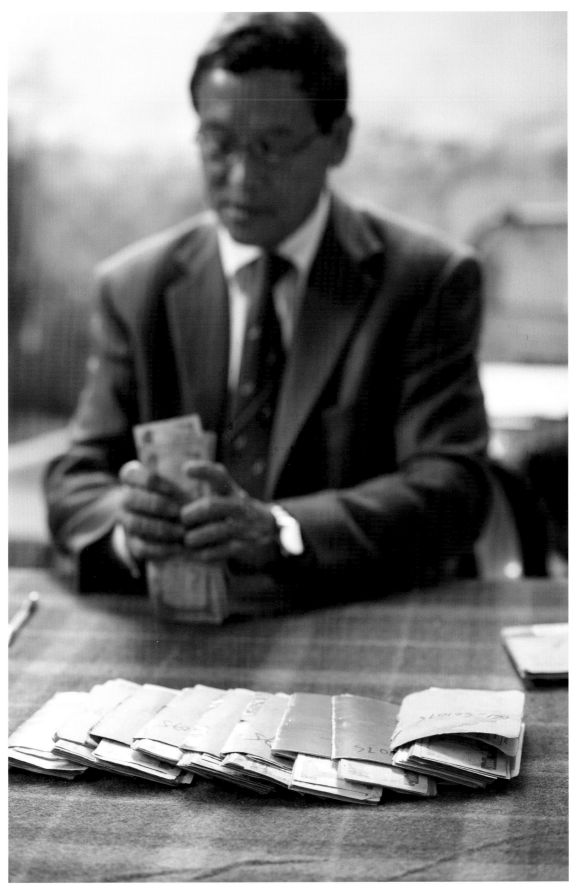

Major Chandra preparing welfare pension payments to former Gurkhas, Baglung, West Nepal, December 2014

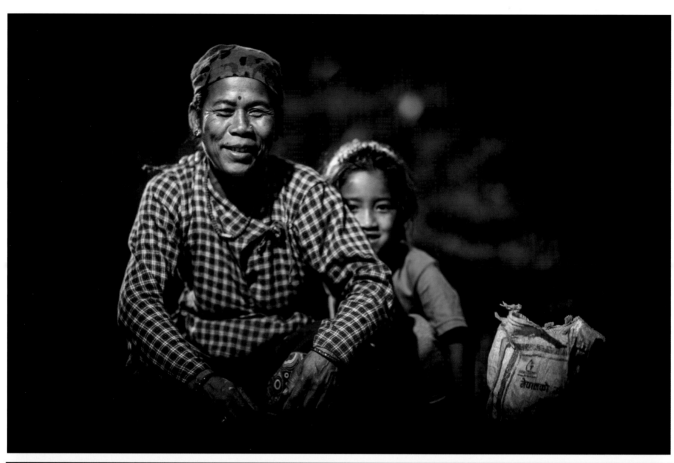

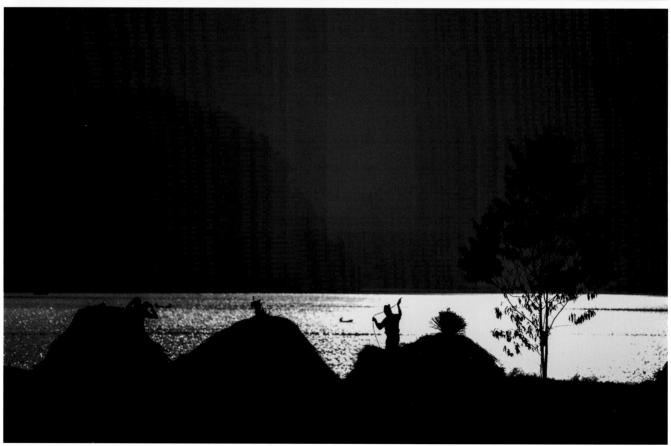

ABOVE AND RIGHT: *Preparing the fishing nets, Pokhara, January 2013*

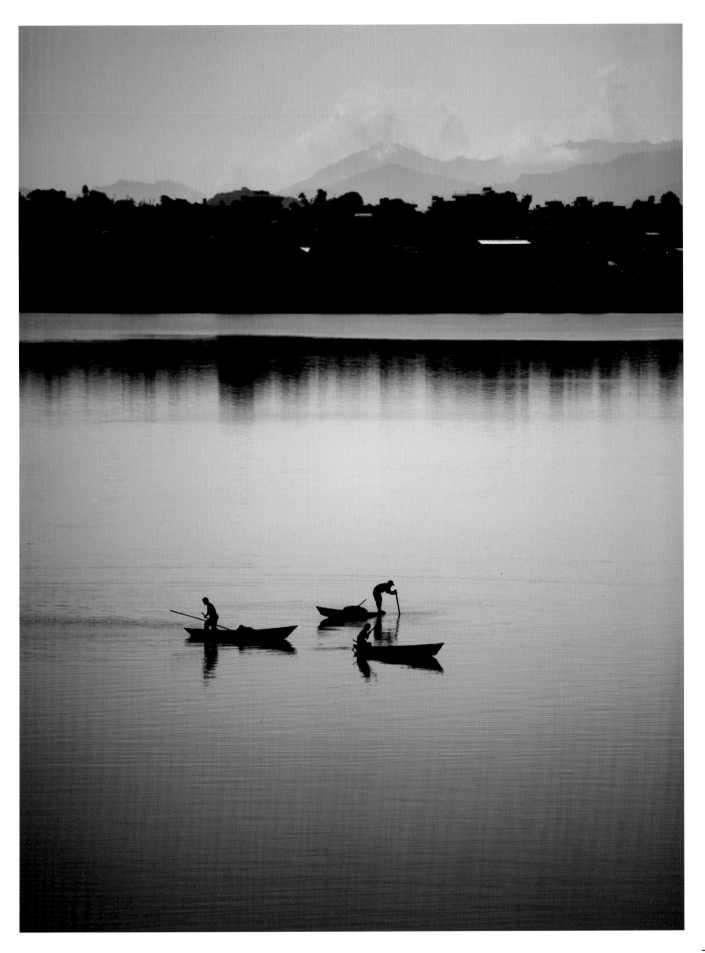

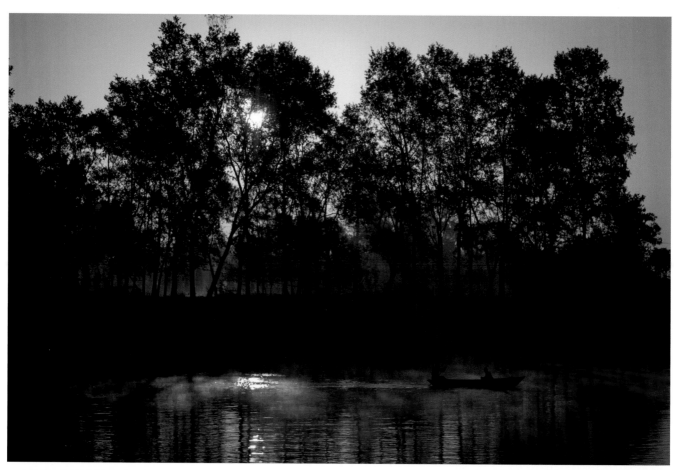

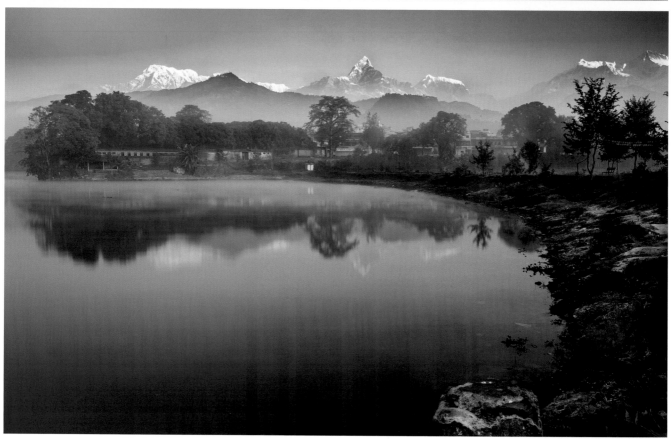

The Annapurna Mountain range, from the Fewa Lake in Pokhara

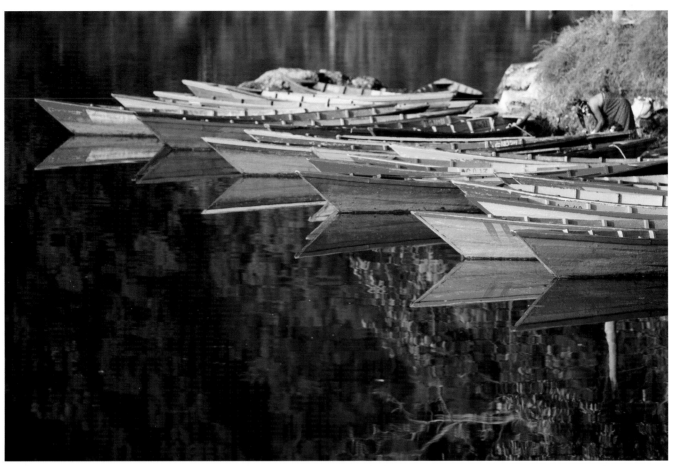

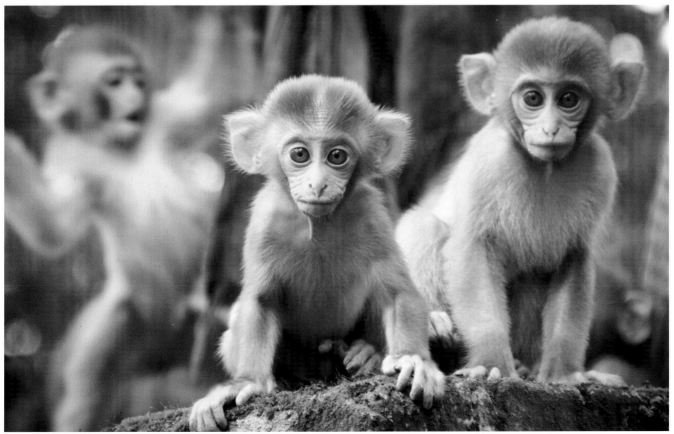

Monkeys, Darjeeling, September 2011

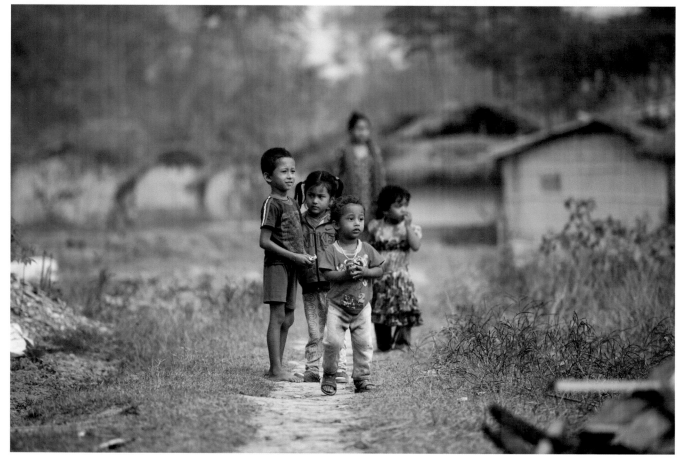

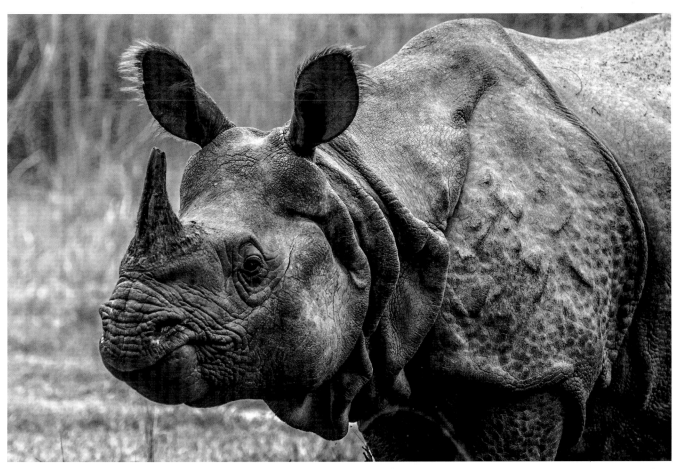

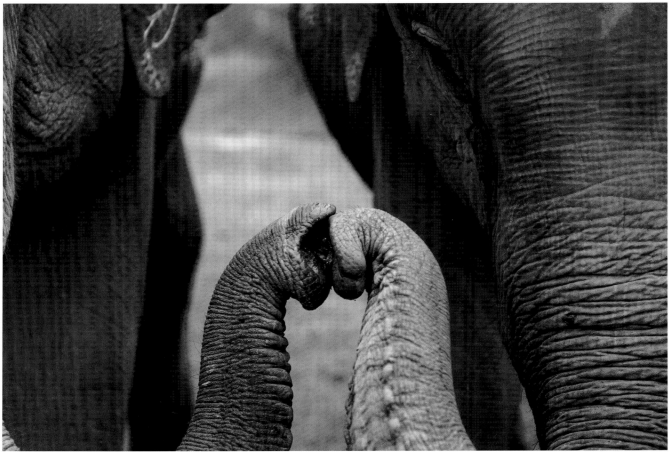

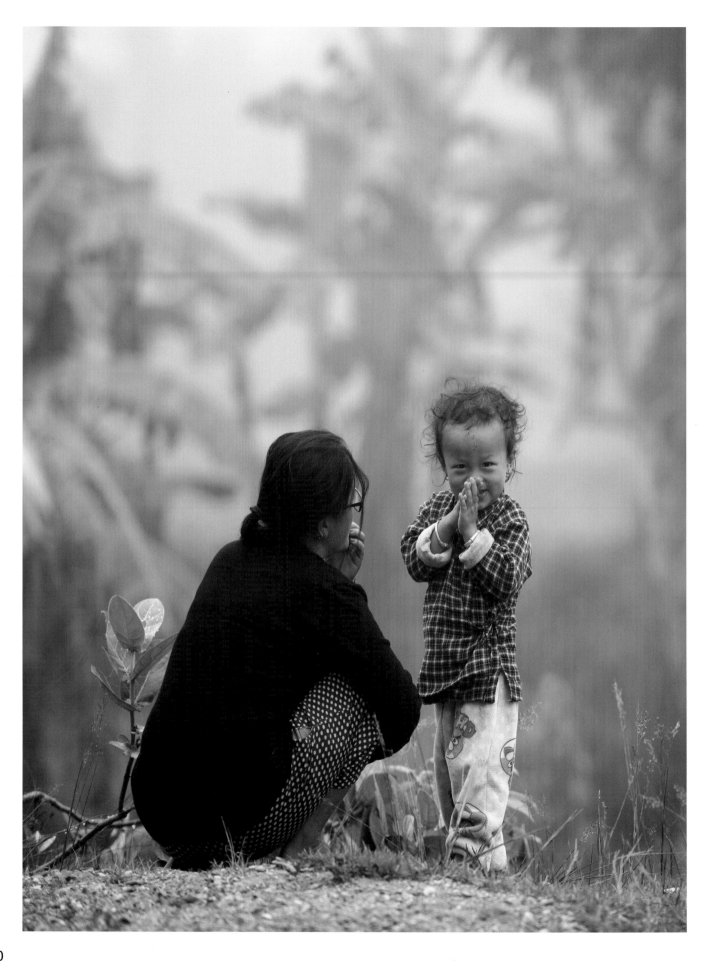

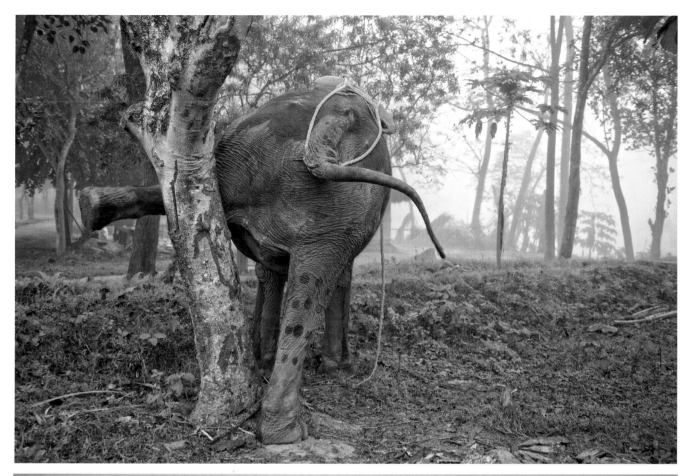

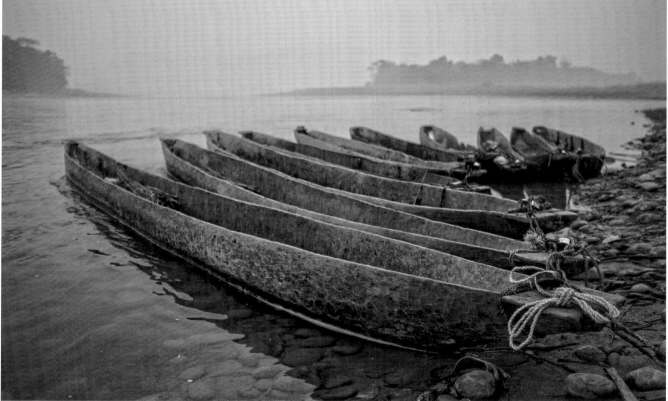

ABOVE: *Scratching post!*
BELOW: *Narayani River, Chitwan*

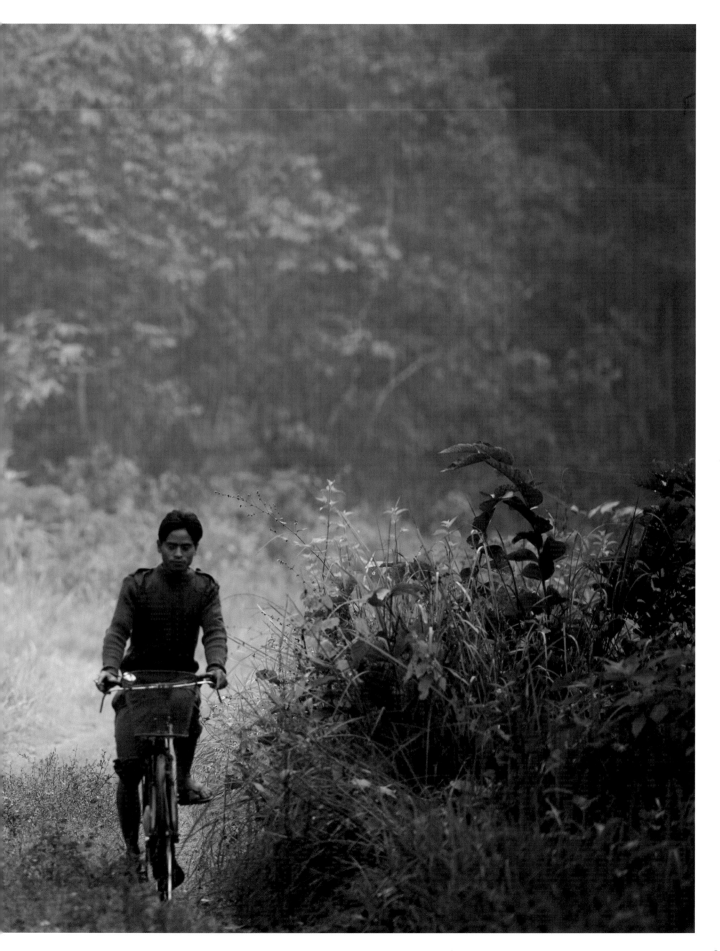

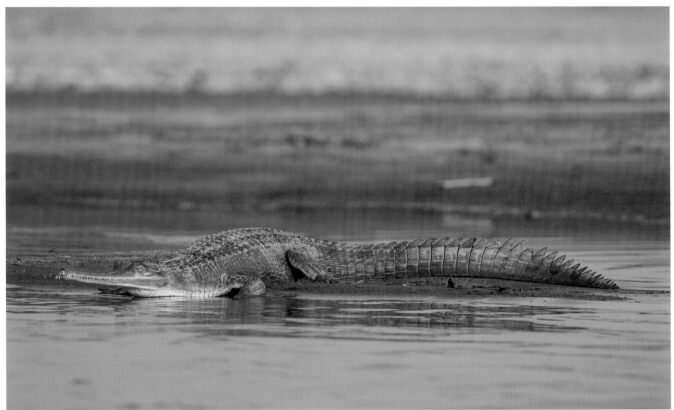

The critically endangered, fish-eating Gharial Crocodile. Their population has declined 97 per cent over the last three generations. Only roughly 200 remain globally

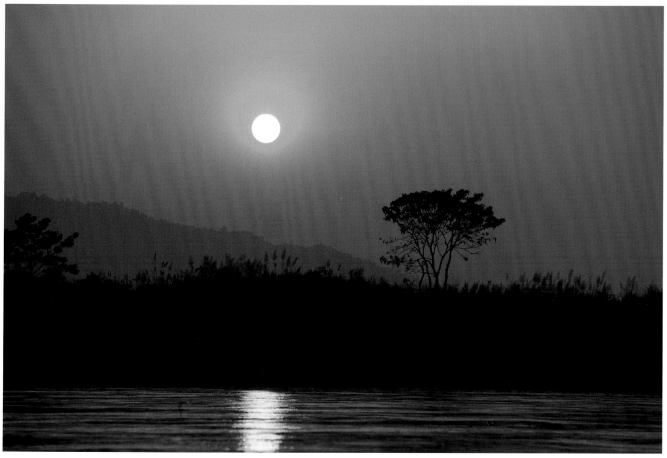

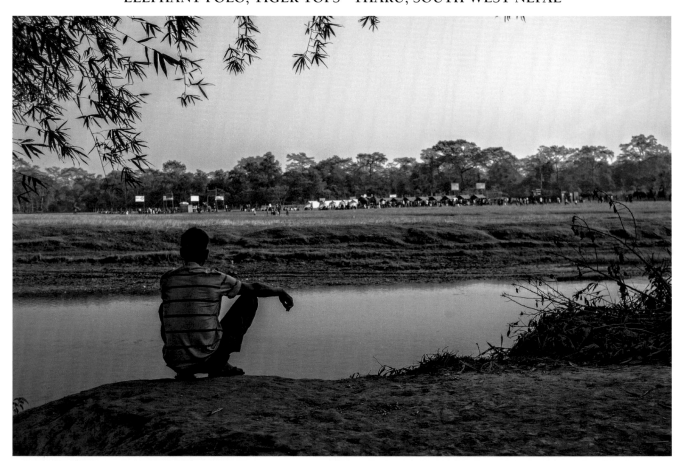

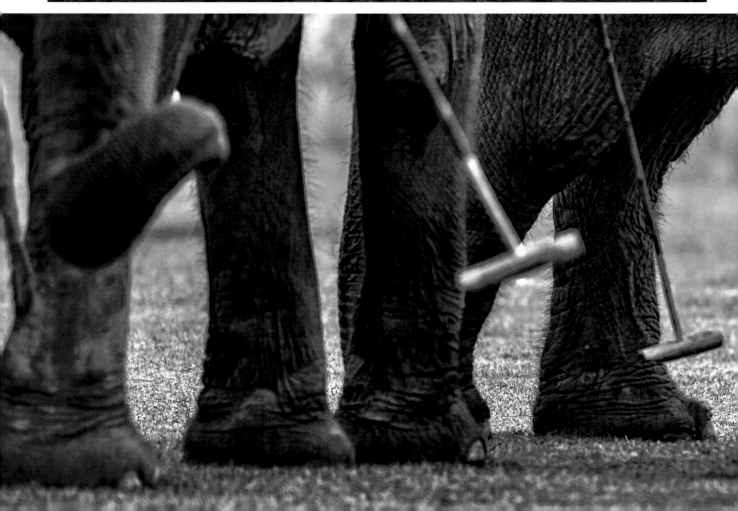

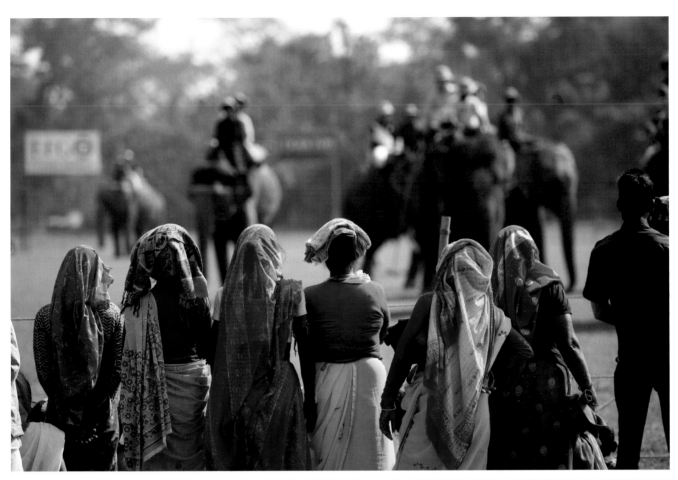

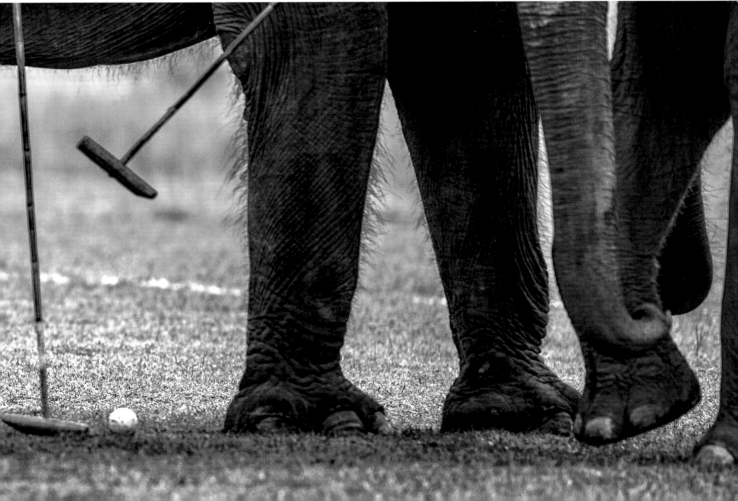

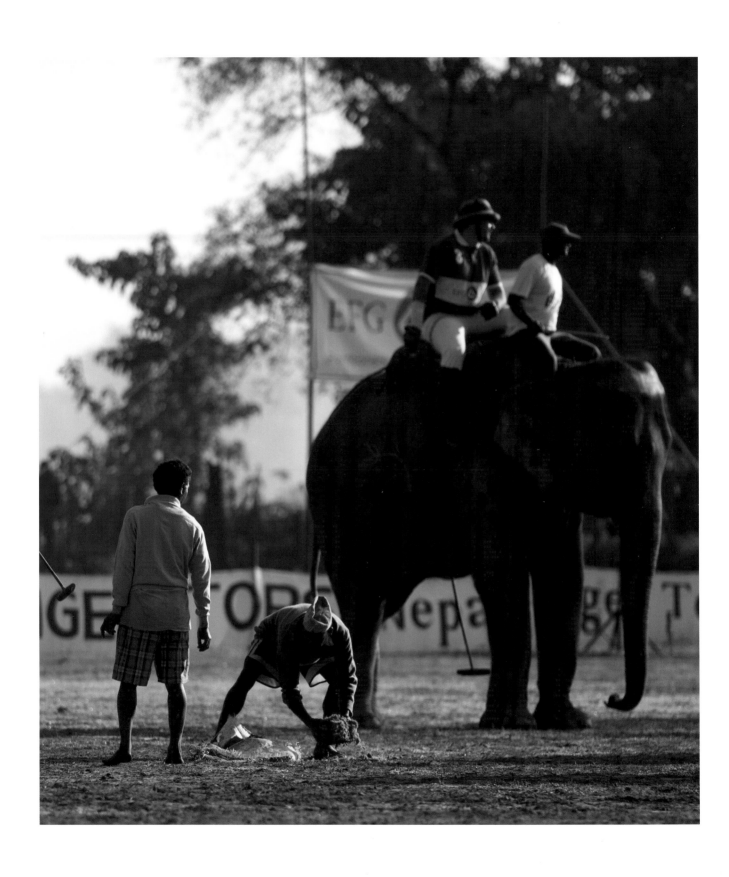

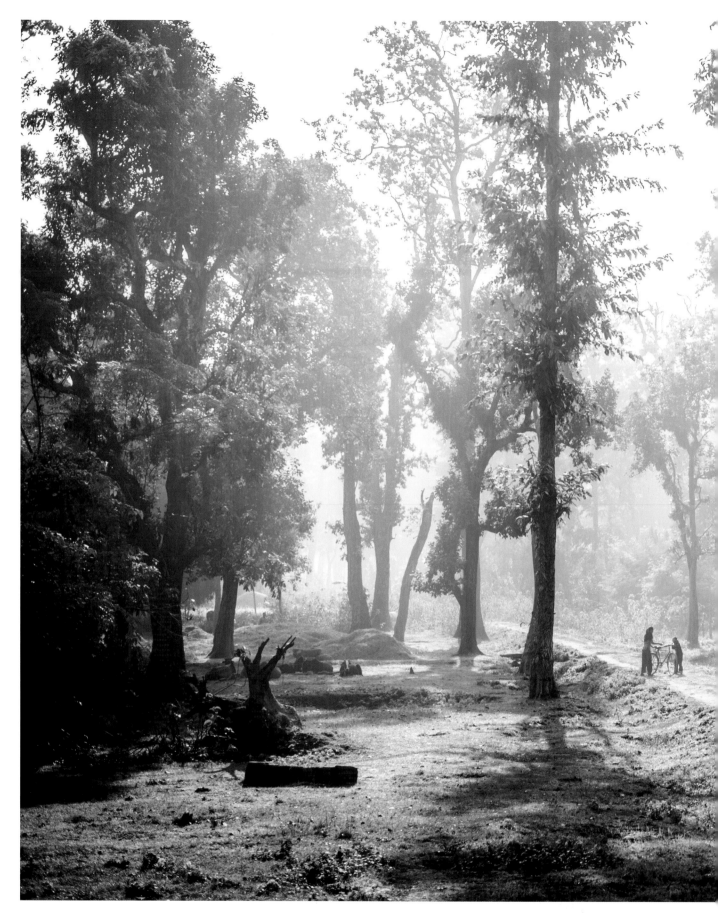

Elephant Transport, Bardiya, West Nepal, December 2013

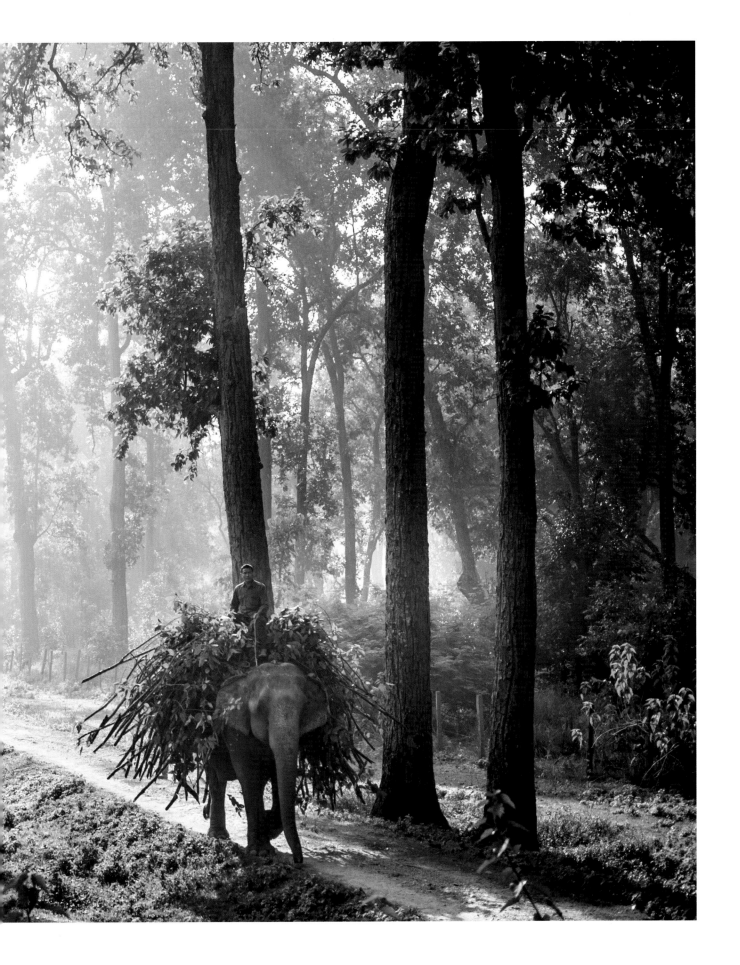

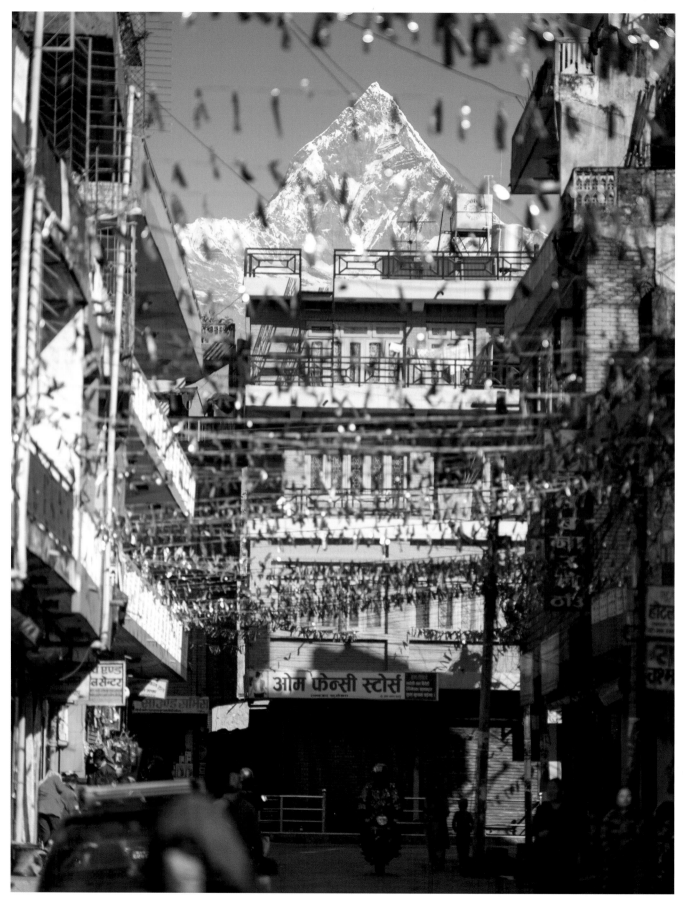

Machhapuchhre from Pokhara, West Nepal, December 2013

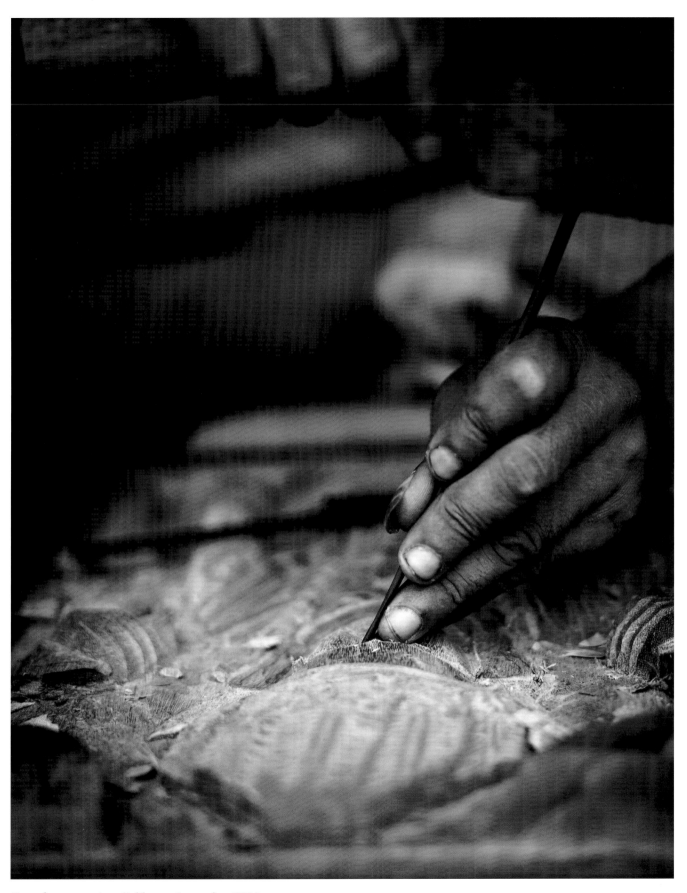

Door frame carving, Pokhara, September 2011
These skills will be in demand if earthquake repairs to ancient buildings are to be done properly

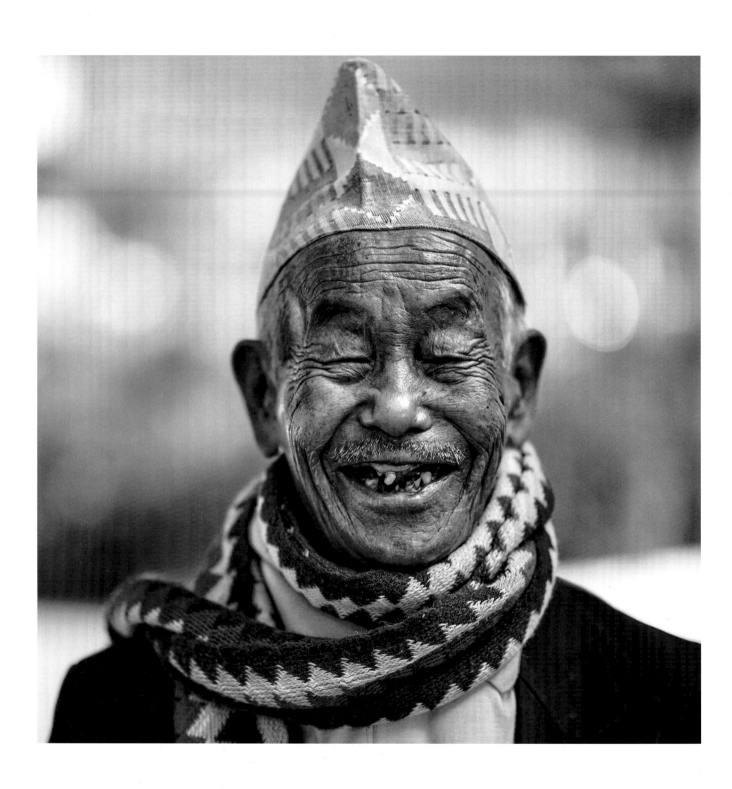

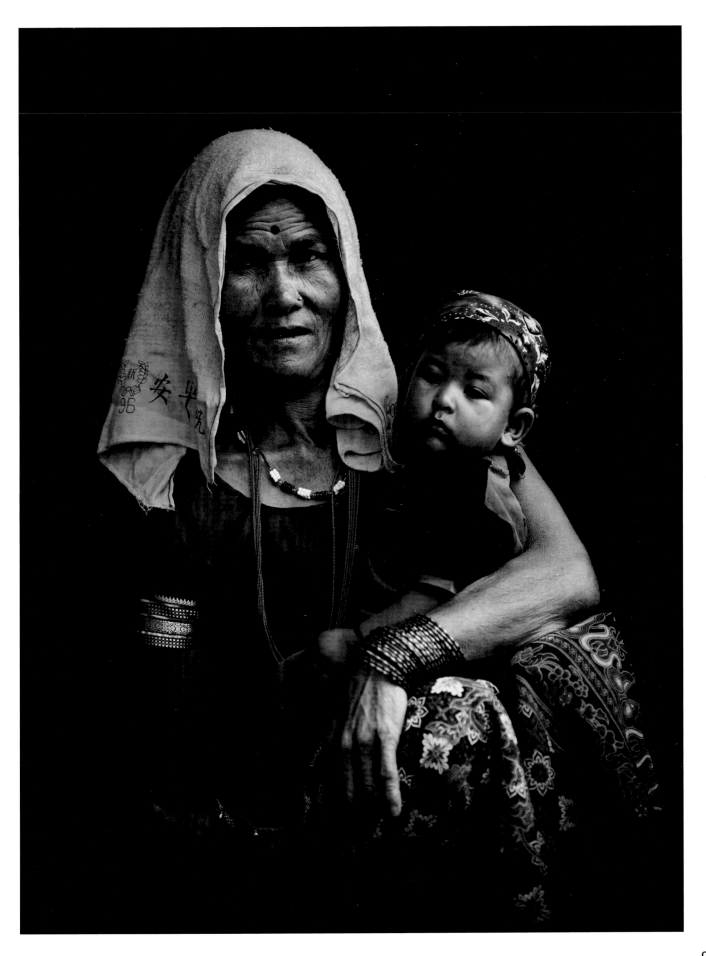

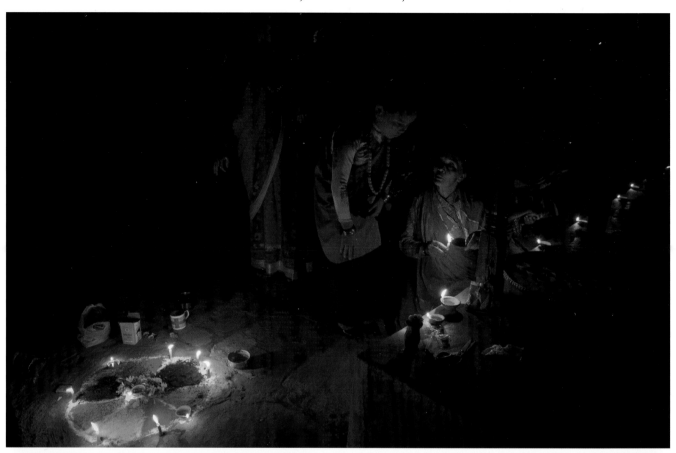

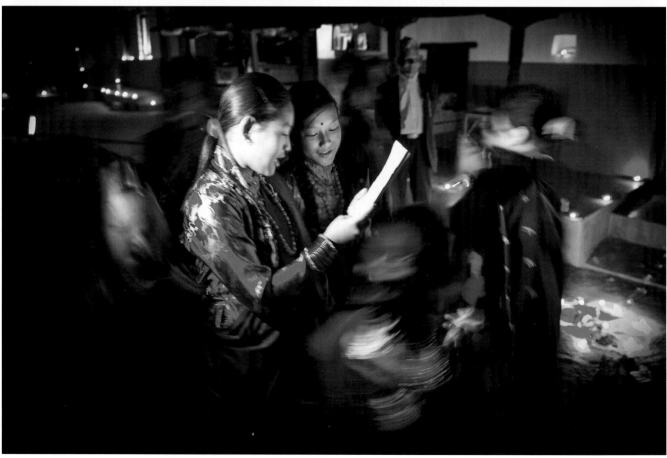

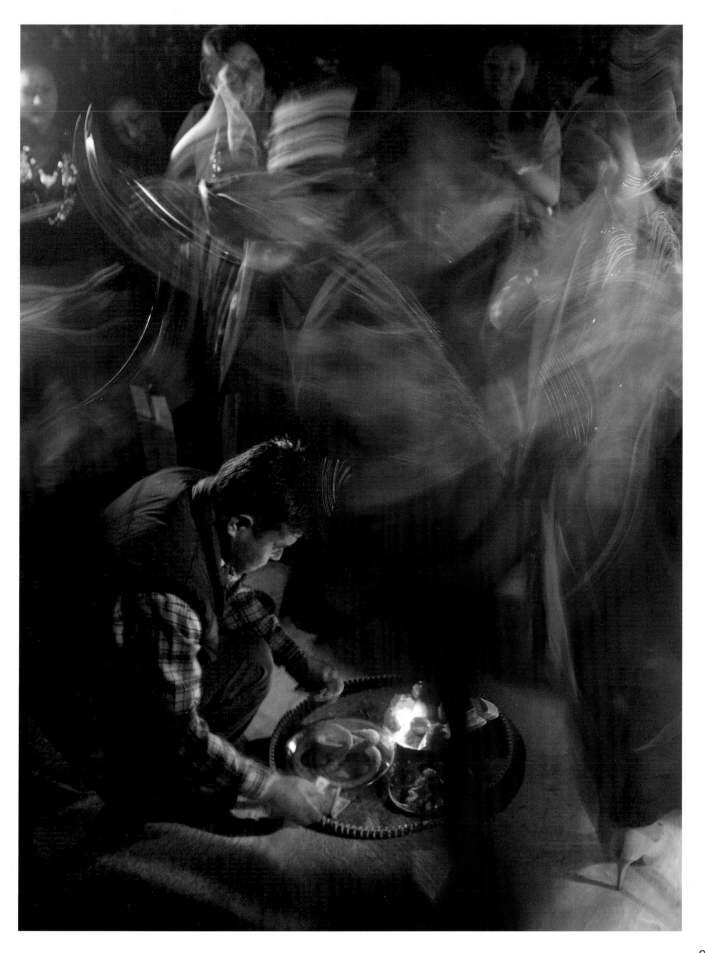

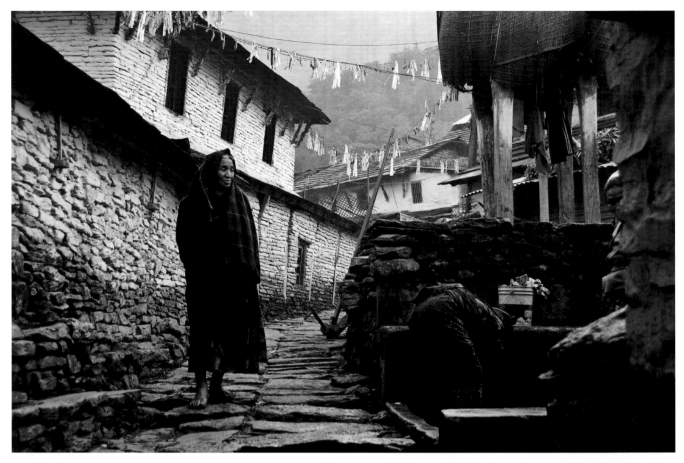

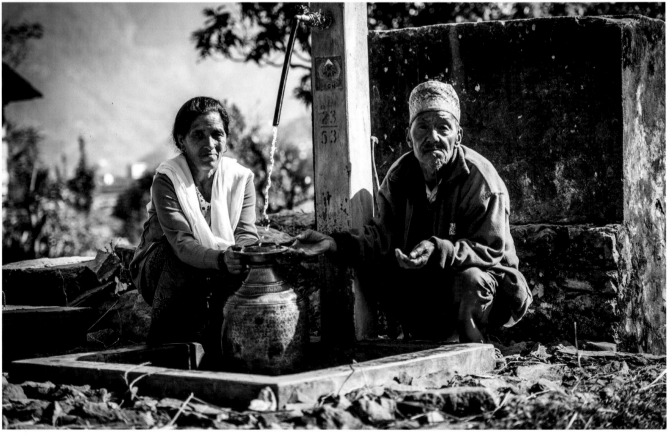

ABOVE: *Early morning walk, Bhujung, West Nepal, November 2011*

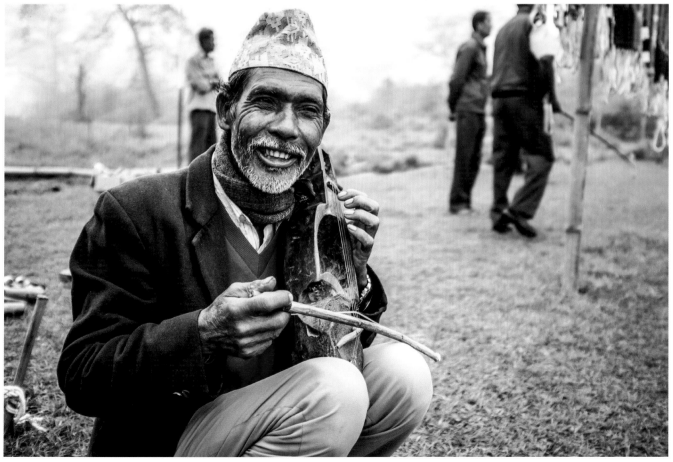

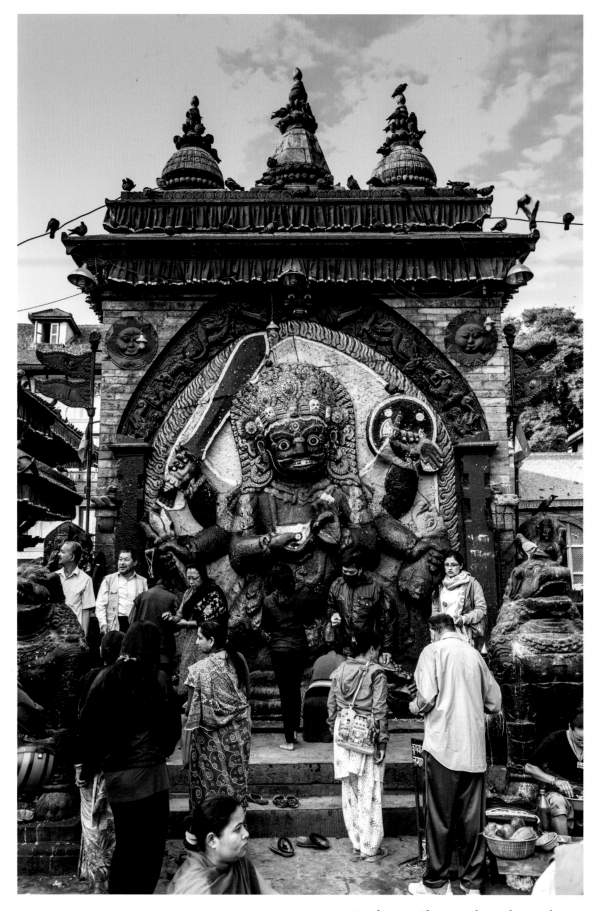

Worshipping Shiva, Kathmandu, April 2015

GURKHA SELECTION, THE DOKO RACE – BRITISH GURKHAS CAMP, POKHARA

There are many tests that potential Gurkhas have to go through to stand a chance of joining the British Army. Firstly, there are the simple things – they have to be at least 158cm (5ft 2in) tall and have no more than four fillings, gaps or false teeth. Doctors will ensure that any old injuries are assessed in detail, and their general medical health has to be very good – not least because the rigours of the testing could make things worse. Following that is the requirement to run 800m in two minutes 45 seconds, to complete 70 sit-ups within a time-limit, and 12 straight-arm pull-ups. They are interviewed in English and Nepalese, and if they fail, they can reapply until they are age 21.

Probably the hardest part, and certainly the most anticipated, is the famous Doko Race. This is a 5 km run, almost all of which is uphill, while carrying a 25kg Doko; the traditional basket usually used for carrying firewood, or feed for the buffalo. This run must be completed in under 48 minutes.

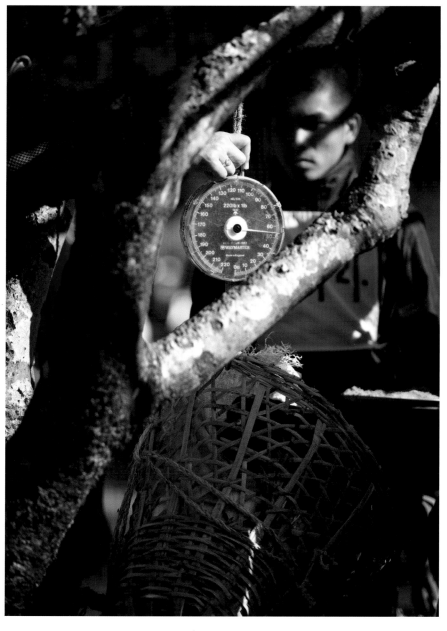

Weighing the Doko – 25 kg

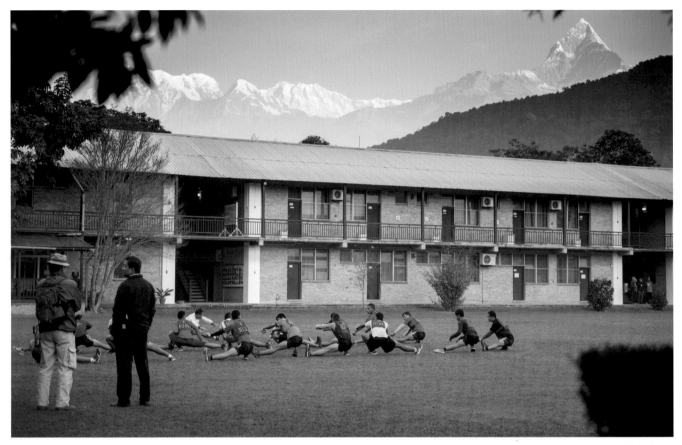

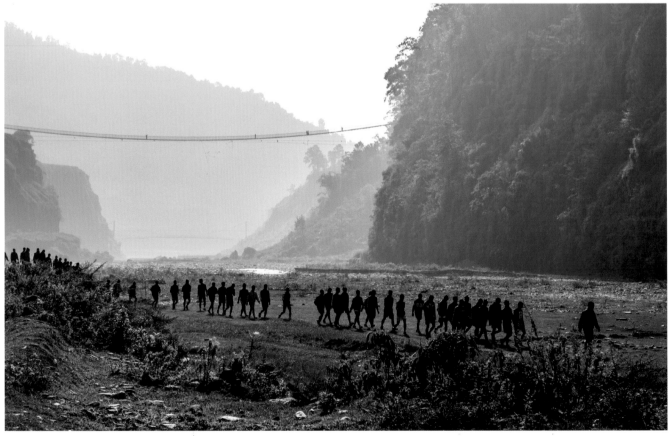

ABOVE: *Warming up*

BELOW: *Preparing to start*

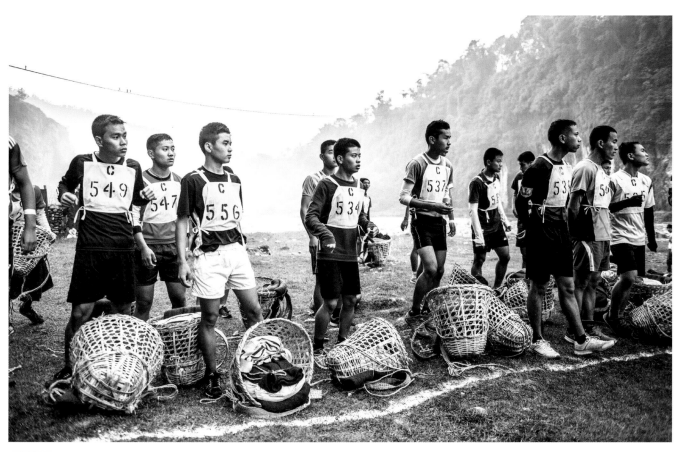

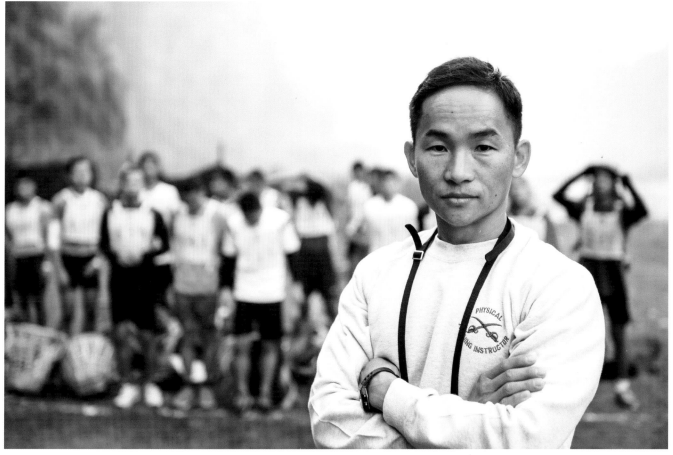

The Start line

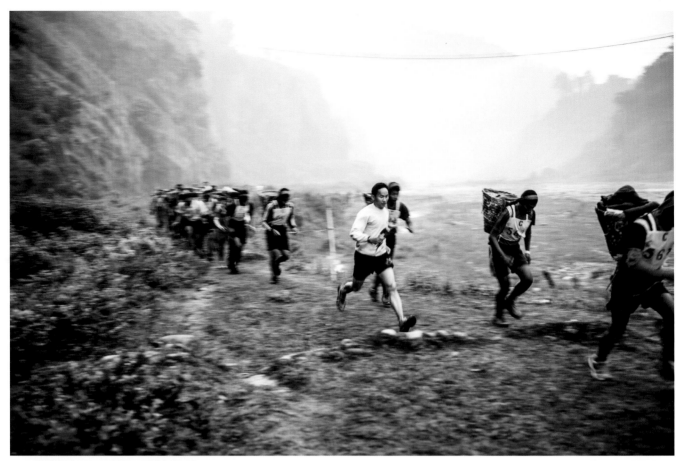

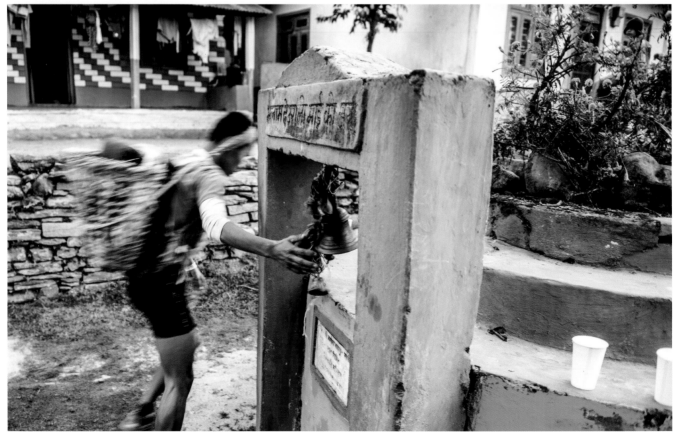

Ringing the bell for luck

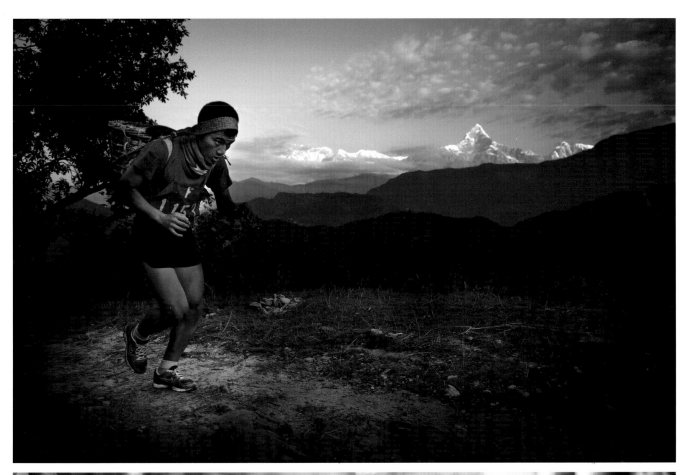

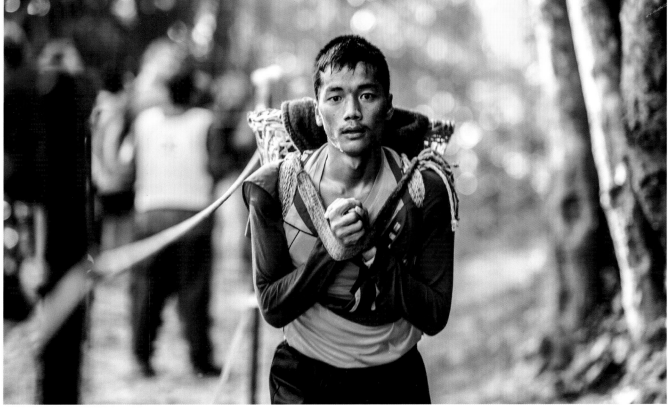

ABOVE: *Half-way, December 2011*
BELOW: *The Finish Line, December 2014*

THE NEPAL EARTHQUAKE

At four minutes before midday on Saturday 25 April 2015, an earthquake with a magnitude of 7.8 hit Nepal with the epicentre based roughly half-way between the two largest cities of Kathmandu and Pokhara, in the north Gorkha district of Nepal.

Barpak is a hill town at about 1,800 meters with a number of shops and businesses. It was, coincidentally, the home of one of the Victoria Cross holders; Captain Gaje Ghale (1918-2000) who won his VC in Burma in 1943. Barpak was also the town right at the epicentre of the earthquake. Before the earthquake there were over 1,200 houses. After April 2015, there was hardly a single home left standing.

Kathmandu also suffered significantly (the whole city moved three metres in 30 seconds) and some of the old wooden temples that had stood for centuries were destroyed. Pokhara, very fortunately, was not badly affected.

Almost 9,000 people were killed as a result of the first earthquake. It had been expected for some time, but poor building design has been a problem for years and many buildings were never going to cope in a medium to large earthquake. If there was any "luck" from this event, it was that the earthquake occurred in the middle of the day when most people were out of their houses and tending the land, and because Saturday is the only non-school day in Nepal, there were no children in school at the time. Almost every school in the rough vicinity of the earthquake was completely destroyed. There were many significant aftershocks every day, culminating in the second major earthquake with a magnitude of 7.3 on 12 May 2015.

Just over a week after the first earthquake, I was asked by the Gurkha Welfare Trust to head to Barpak and record the effects of the earthquake so they could properly assess what support might be needed.

I arrived in Kathmandu and spent a day there before moving to the Gorkha district. I travelled around the capital on foot to witness the destruction. The damage at the Kathmandu Durbar Square was significant and some of the old temples were in ruins. In fact many of the old buildings had suffered significant damage, with huge cracks in the walls and collapsed roofs.

I travelled by road to Gorkha (it was odd to see the roads so clear of traffic) and continued on foot to the beginning of the climb up to Barpak. Usually one could get further by vehicle, but the earthquake caused a landslide that destroyed the road. Then the only way up was on foot. I carried

my photographic equipment for four very hot hours. The sun was blazing in that pre-monsoon way, and the temperatures were approaching 30 degrees. One of the significant rest points for people travelling between Barpak and the villages towards Gorkha is called Mandre, at 1400m. It used to be very welcoming. This village was now entirely rubble; the primary school now flat.

When I arrived at Barpak, I found a town where virtually everyone had lost their houses. In fact everyone in every village leading up to Barpak had lost their houses. Some aid was starting to get through, in the form of tarpaulins, and some medical teams, which were being very well received and put to good use. The generosity of the people who had been so badly affected was incredible. Despite having lost everything (indeed many goats, chickens and buffalo were killed in the earthquakes), everywhere I went I was offered food and drink. I had my own, of course, so with some difficulty, politely refused. It is once again this sense of acceptance and resolute fortitude that so defines these Nepalese hill people.

I stayed in the village for a number of days and witnessed the desire of the people to get things going again. Without much help they were rescuing what they could from their former houses and re-building (mainly with wooden frames now and lighter roofs as further earthquakes were feared) and they were tending their land and remaining livestock. After all, the monsoon was just around the corner.

On completion, I headed back through Gorkha and on to Kathmandu. I had another day of photographing the city and visiting some of the temporary camps where people from the hills above Kathmandu were slowly and reluctantly gathering.

Six hours after I departed for the UK, on 12 May 2015, the 2nd earthquake hit.

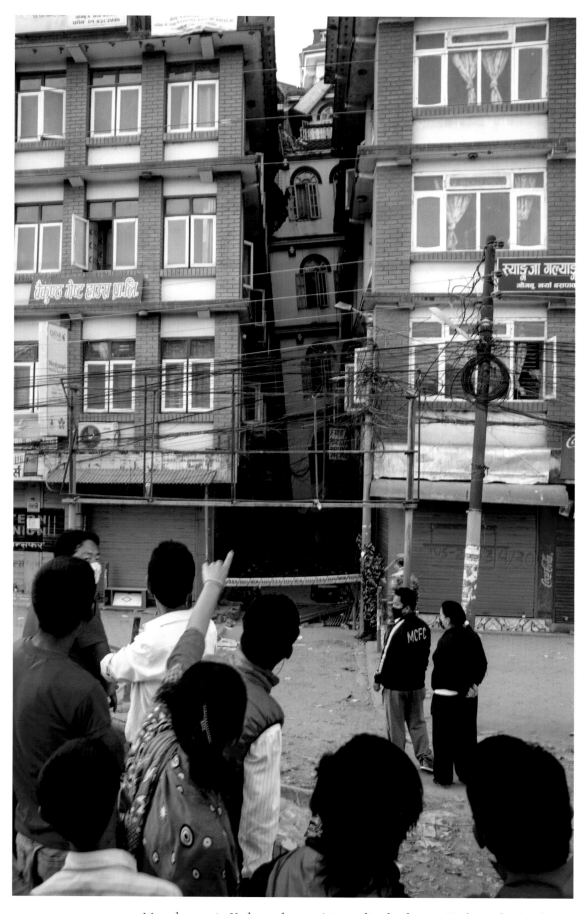

Most damage in Kathmandu wasn't immediately obvious. Kathmandu, April 2015

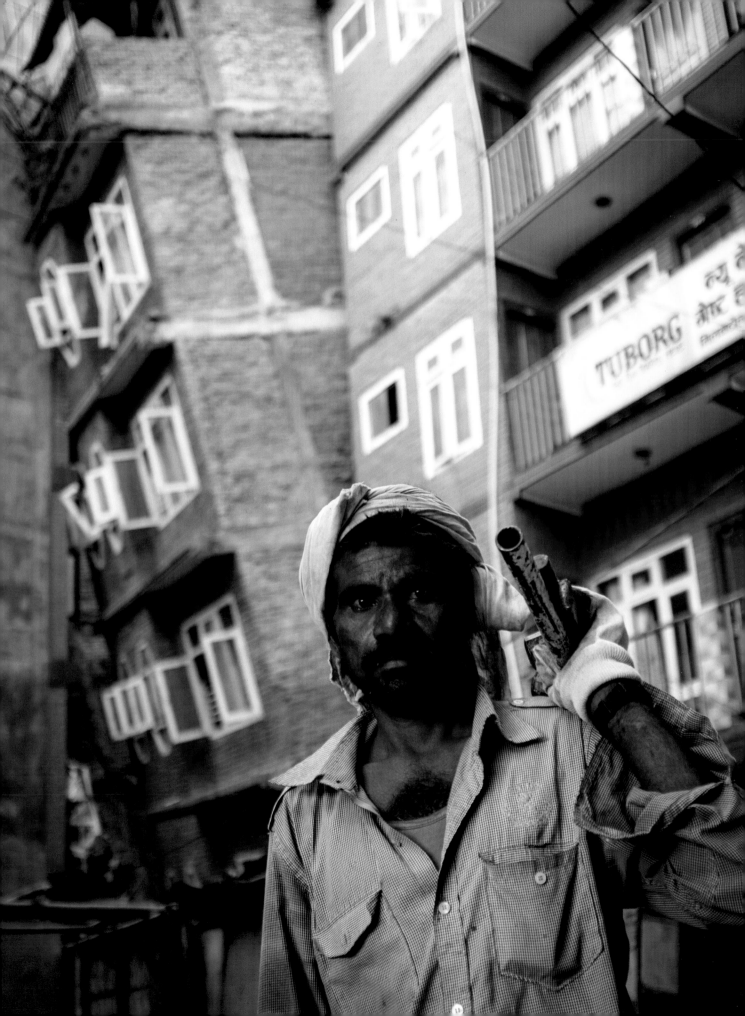

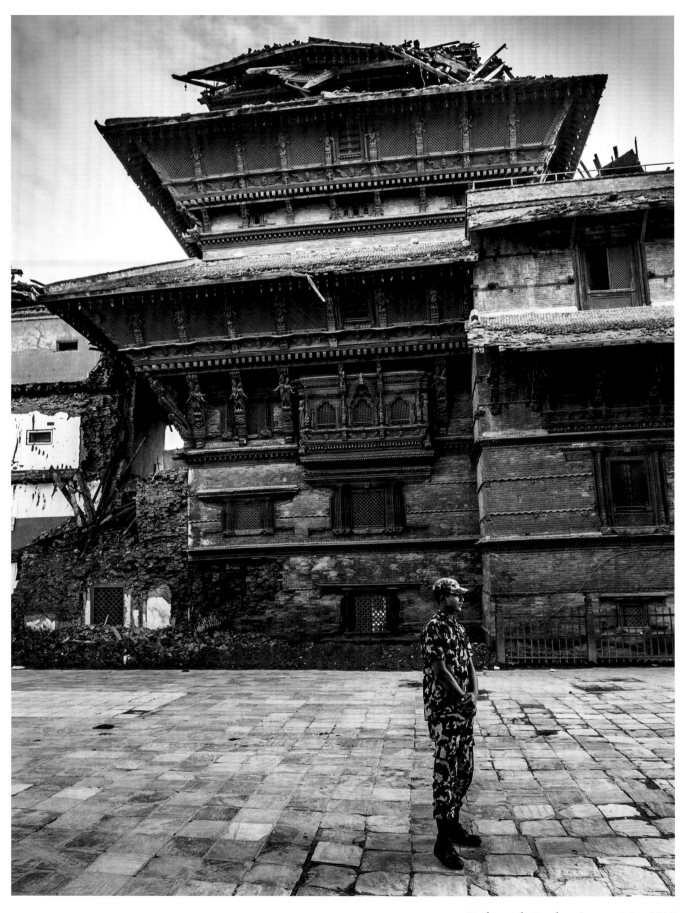

Kathmandu Durbar Square, May 2015

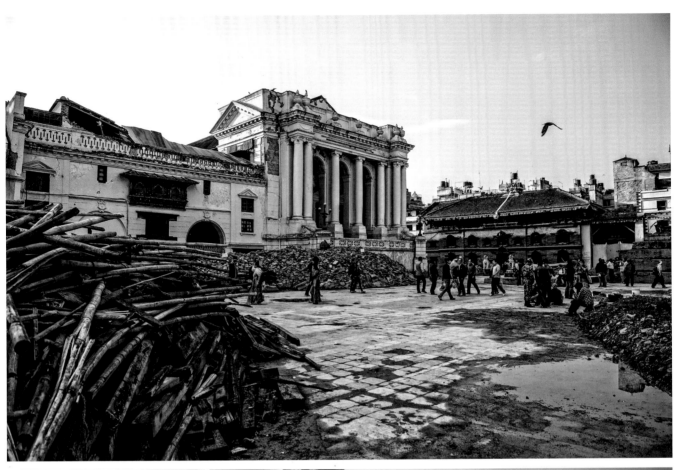

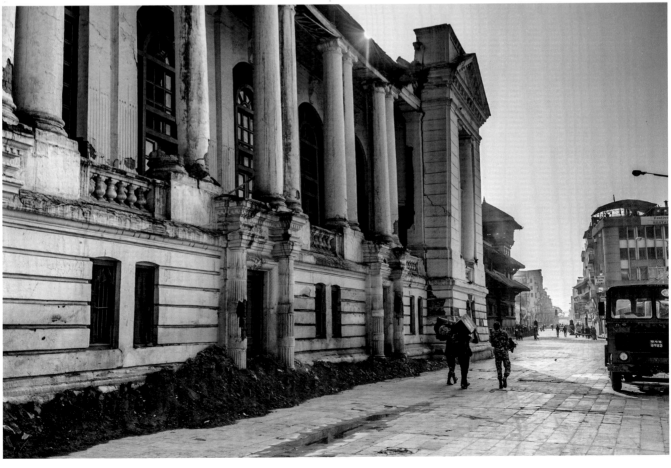

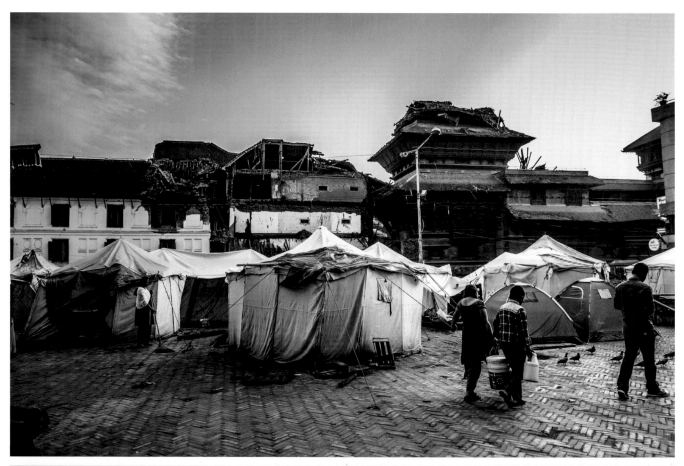

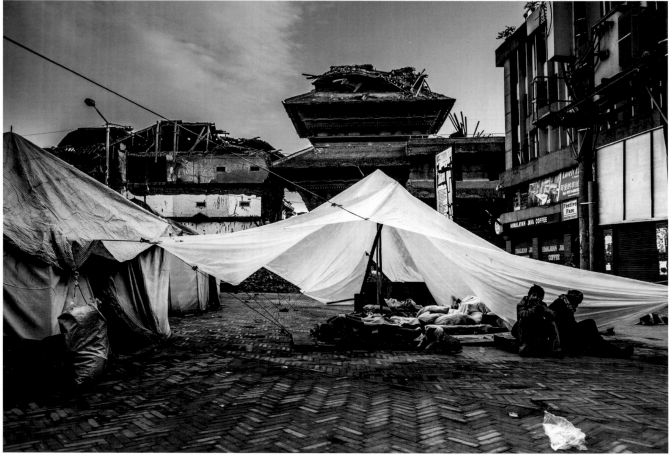

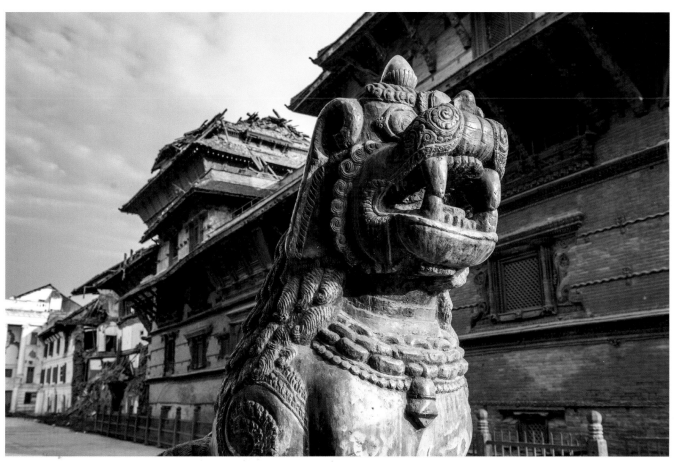

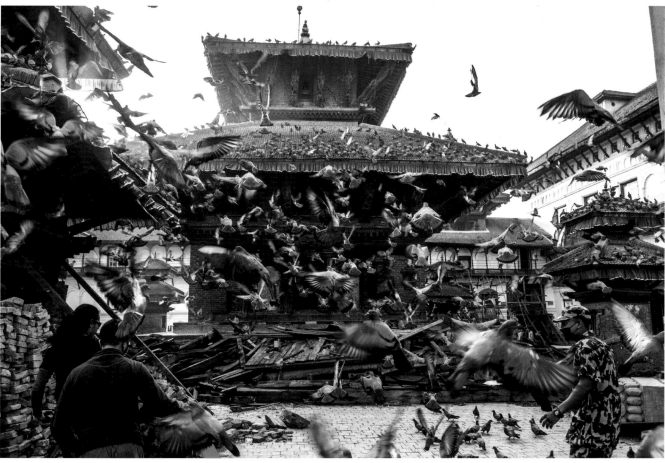

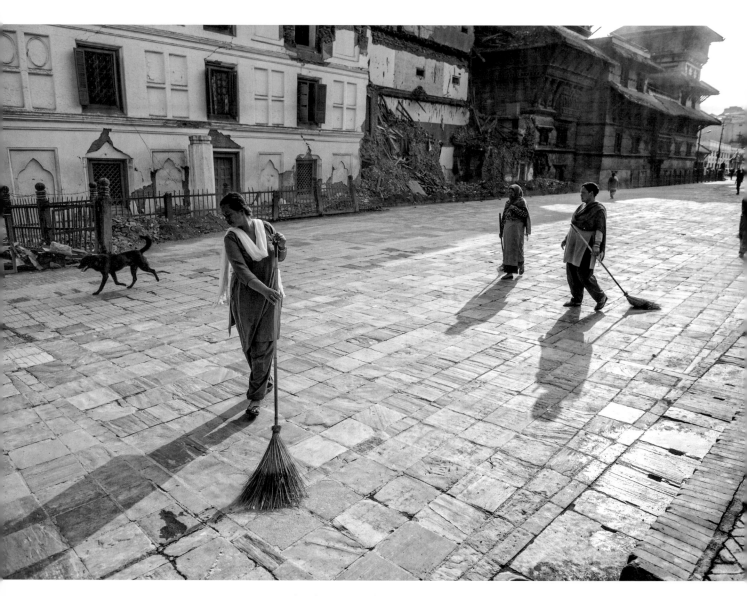

The cleaning and repair was almost immediate despite the significant aftershocks.
This image was taken just one day before the second major earthquake on 12th May

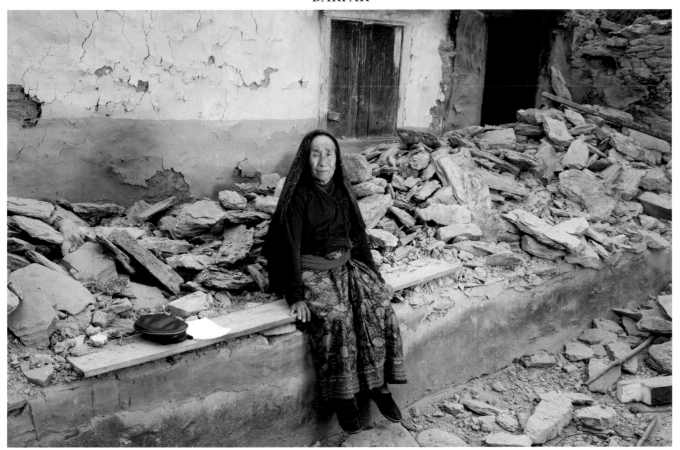

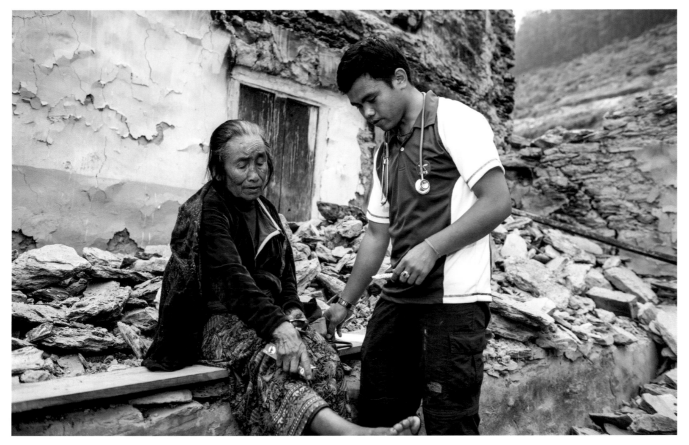

Lady sitting on the remnants of her porch ….and receiving medical treatment from the Gurkha Welfare Trust

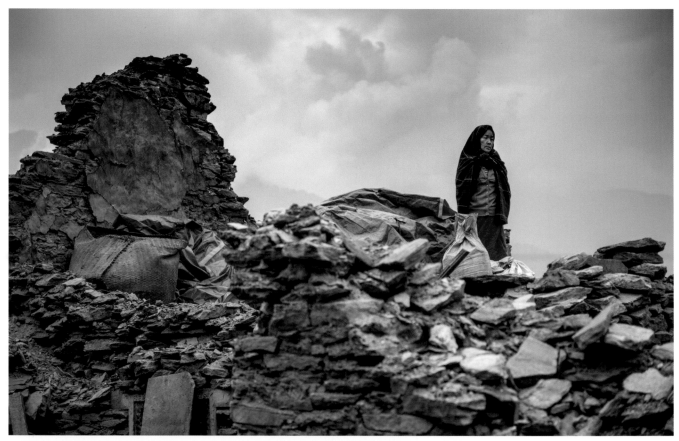

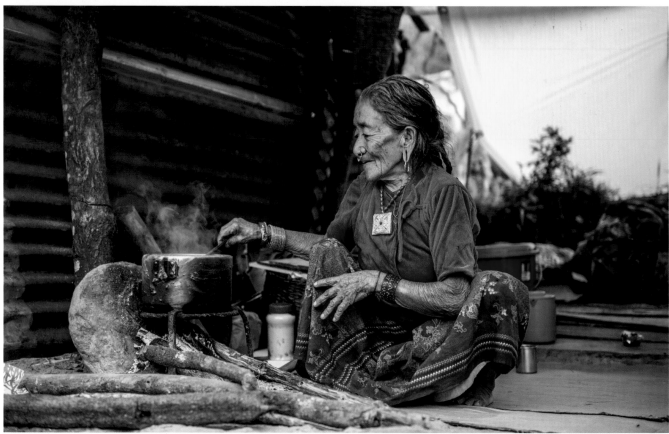

ABOVE: *Tarpaulins from aid agencies arrived quite quickly, and just in time for the monsoon*

BELOW: *Despite all the odds, life had to carry on, even though almost every single building had been destroyed*

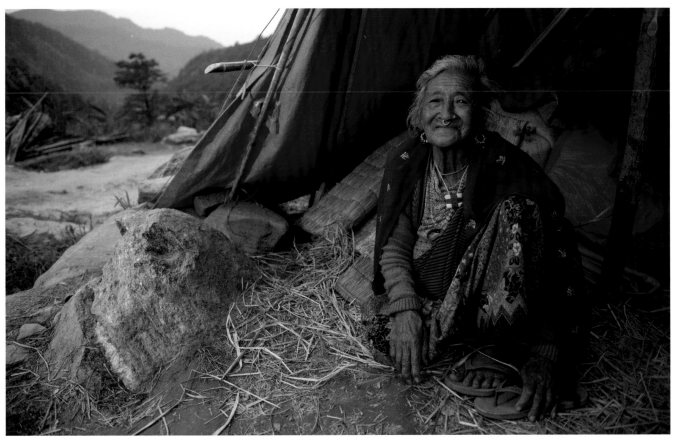

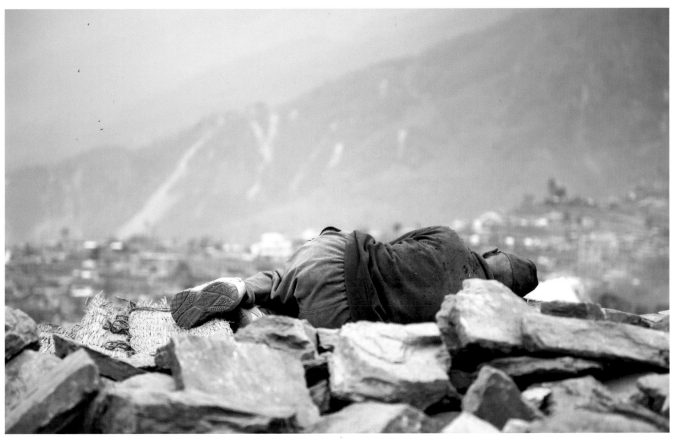

ABOVE: *The elderly were badly effected*

BELOW: *Many exhausted people took rest where they could*

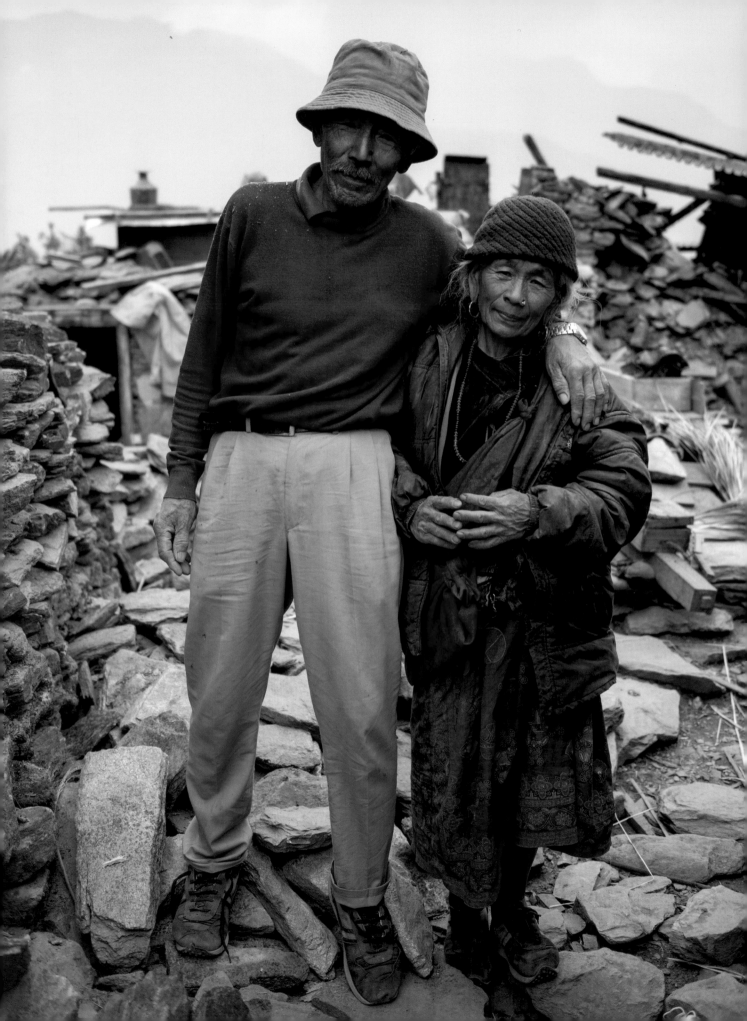

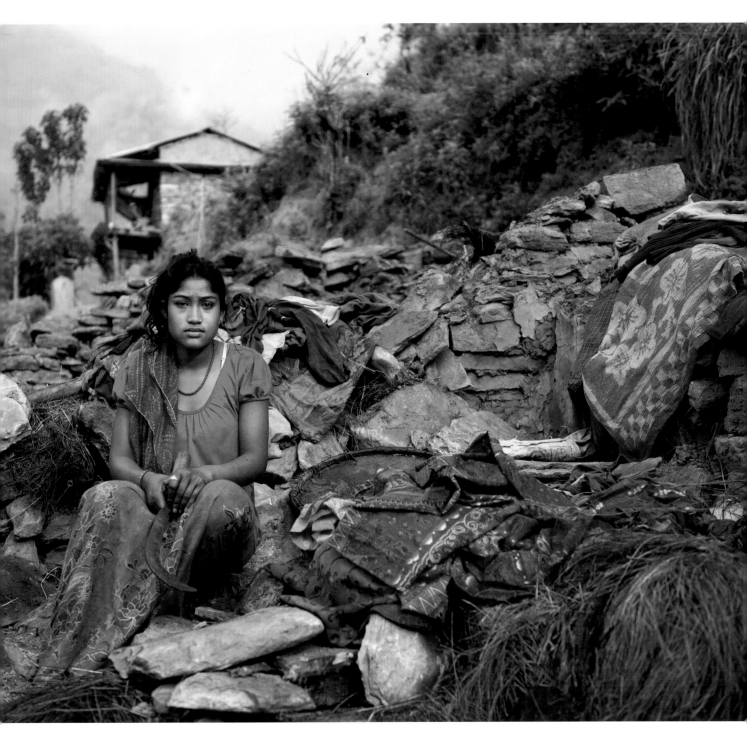

ABOVE: *This girl was searching for her belongings in the remains of her parents' house*

LEFT: *Ex-Gurkha and his wife standing in the remains of their house*

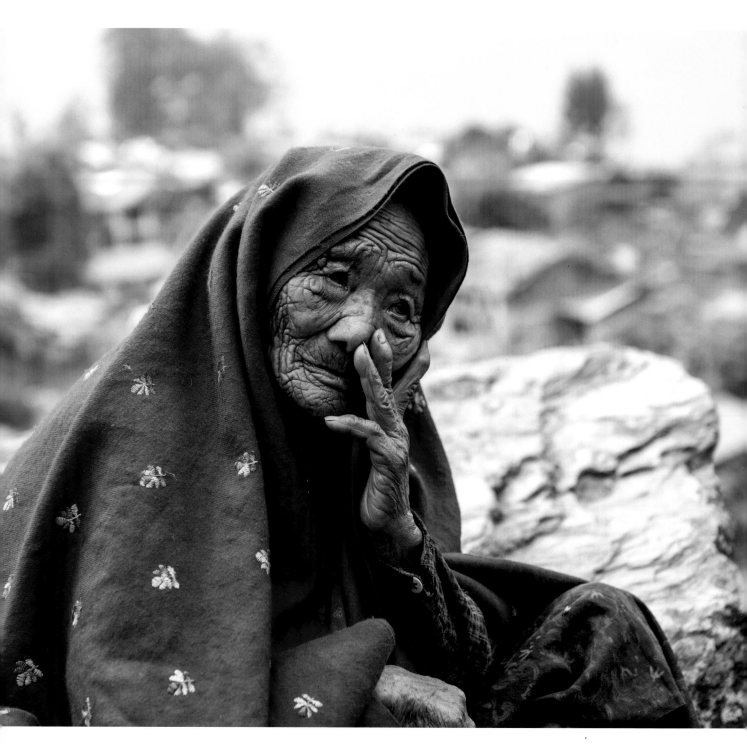

ABOVE: *This lady was sitting on the edge of Barpak, in tears*

RIGHT: *Despite the devastation; smiling still. Her new store room was the only remaining building at her home*

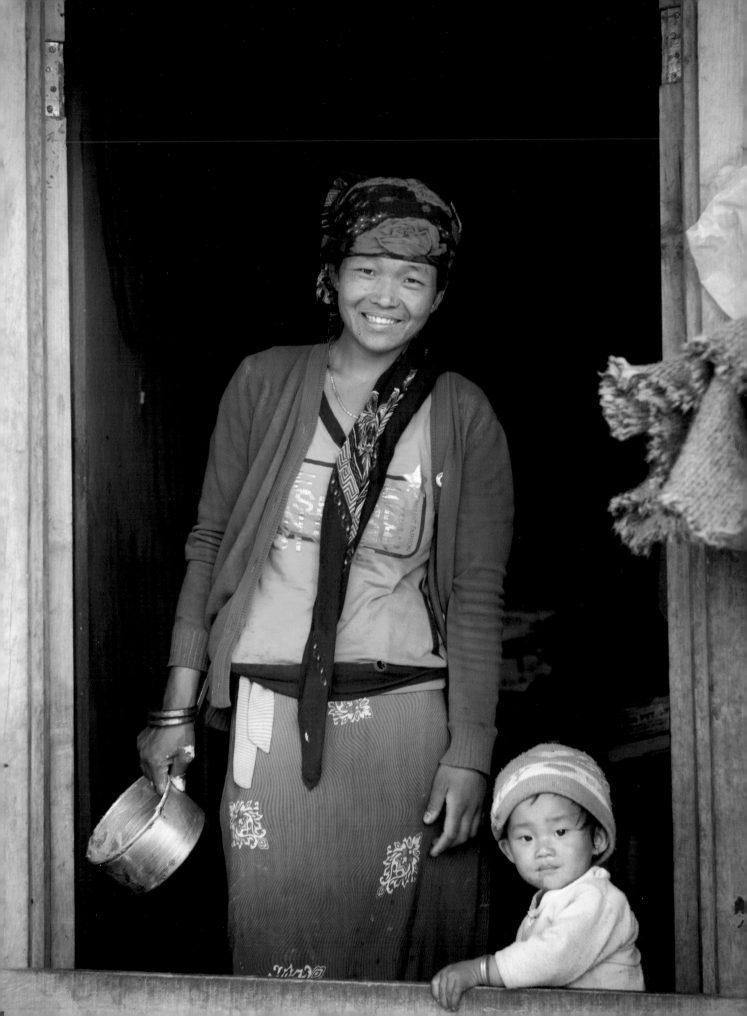

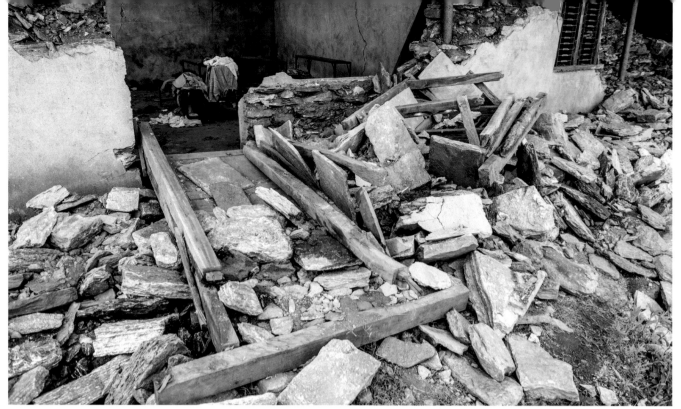

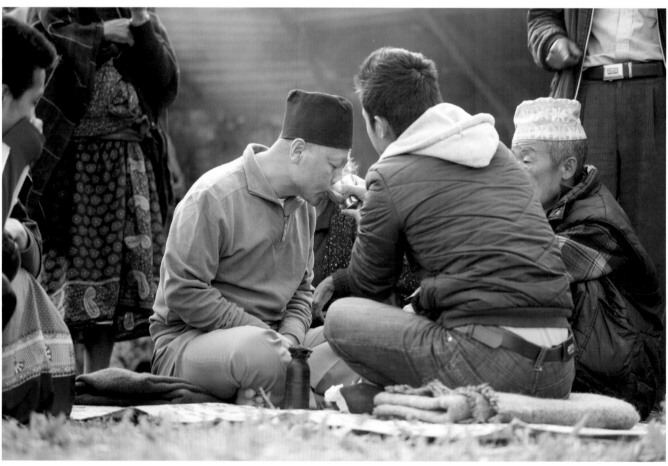

ABOVE: *Every school was destroyed. It was fortunate that the earthquake hit at midday on a Saturday – the only day when schools were closed*

BELOW: *Many funerals were taking place. This ex-Gurkha had returned from work in the UK for the religious ceremony following the death of his father, who was inside his house during the earthquake*

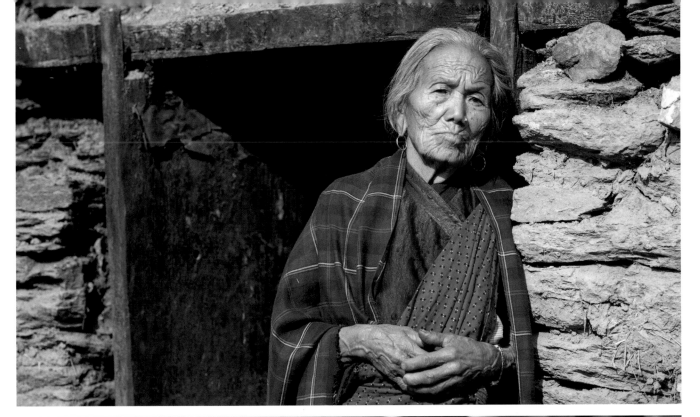

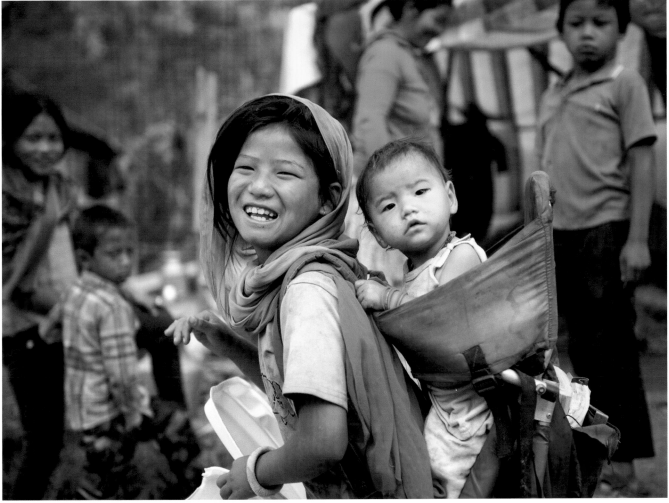

This girl (carrying her brother) was fetching food for her parents while they tried to rebuild their house

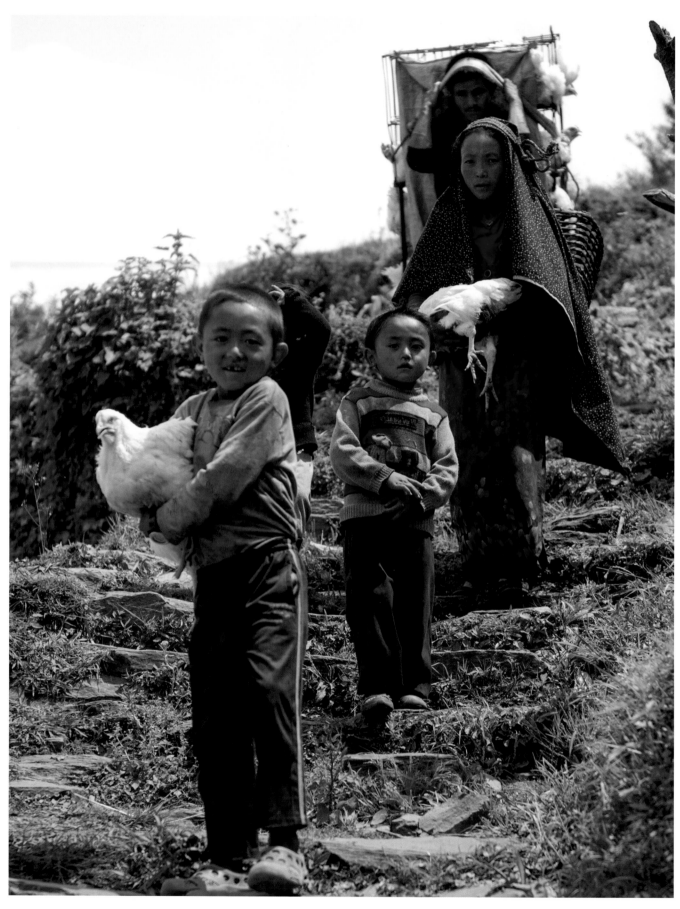

Many families moved from Barpak to safer places immediately after the earthquake

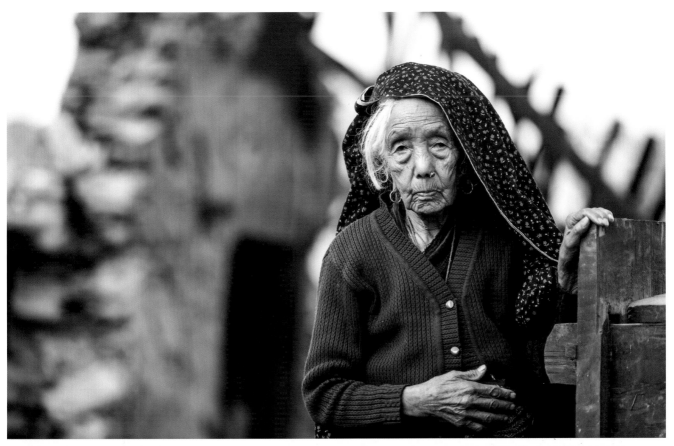

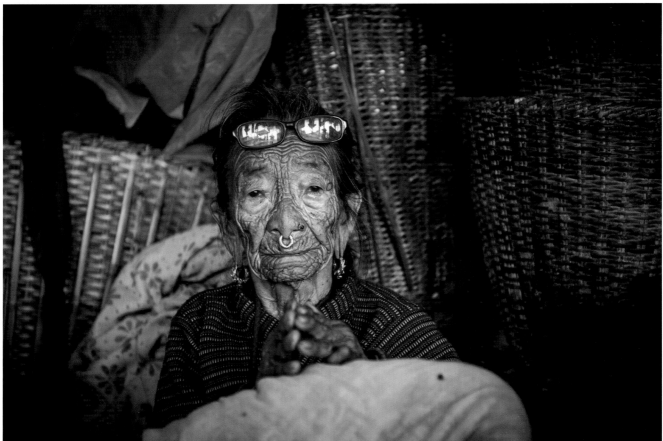

BELOW: *This Gurkha widow had moved into a basket store where I found her sleeping*

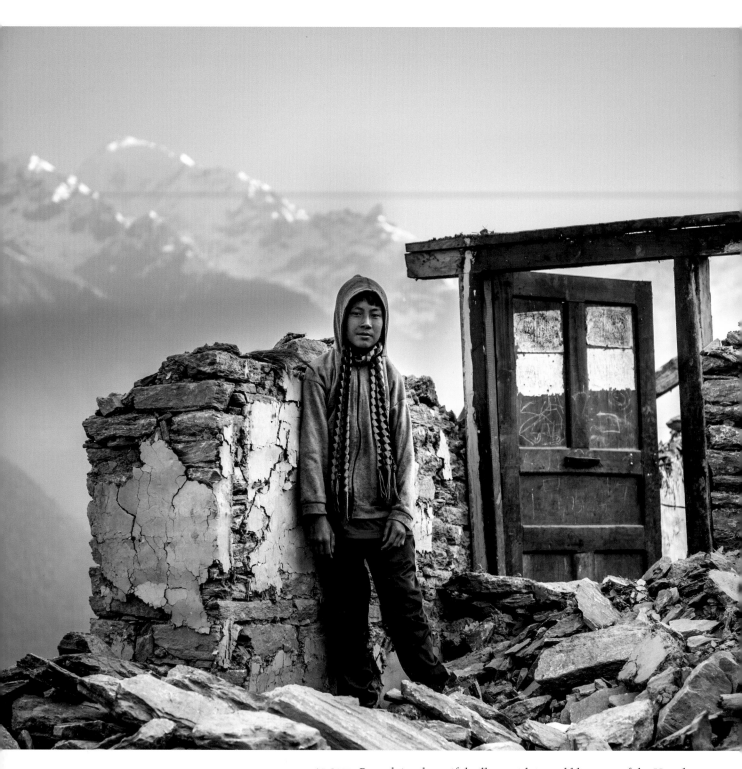

ABOVE: *Barpak is a beautiful village with incredible views of the Himalayas*

RIGHT: *This lady had moved into her cattle shed with her daughter after her house was destroyed. She was incredibly passionate and described the earthquake and the panic that ensued. Her 6-year-old granddaughter was killed and she told me that it should have been her that was killed in her granddaughter's place*

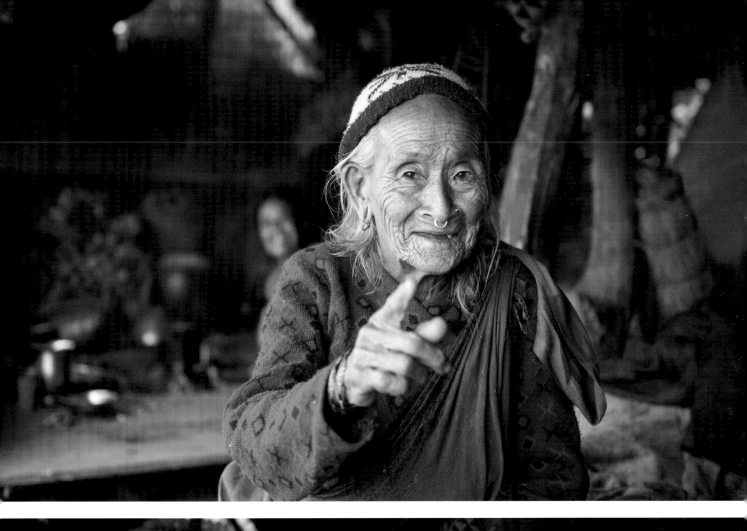
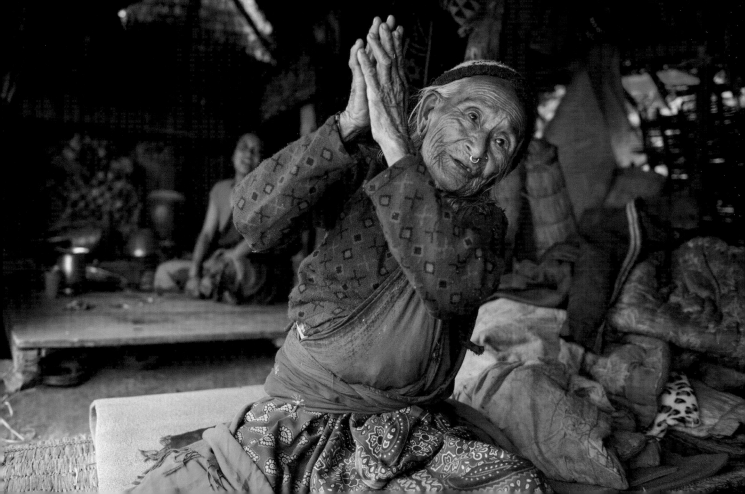

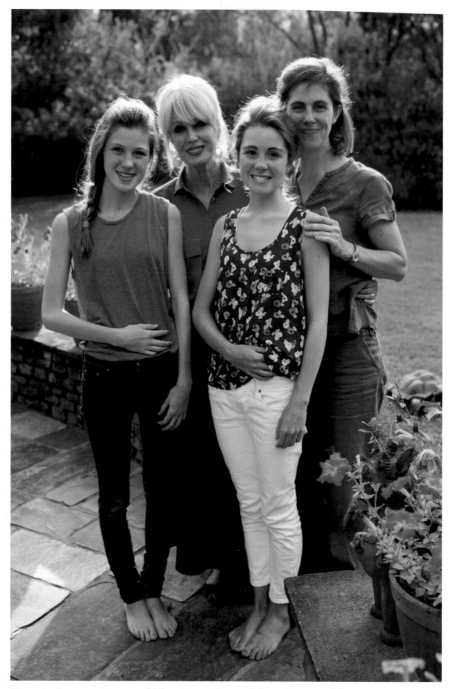

Georgie, Joanna, Lucy, and Blou in our beautiful garden in Pokhara

I have some special thanks to my family. My wife Blou, who has through all of my travels accompanied me where possible and has shown considerable forbearance with both the peculiarities of military life and now the vagaries of living with a freelance photographer. My daughters Lucy and Georgie, who have endured occasional long periods of separation but have always been so incredibly supportive throughout, and have loved their time spent abroad with us. I know all three of them have a special place in their hearts for Nepal and the Gurkhas.